Creative Digital Crafts

First published in the United Kingdom in 2005 by
ILEX
3 St Andrews Place
Lewes
East Sussex BN7 1UP

ILEX is an imprint of The Ilex Press Ltd
Visit us on the web at:
www.ilex-press.com

ILEX Editorial, Lewes:
Publisher: Alastair Campbell
Executive Publisher: Sophie Collins
Creative Director: Peter Bridgewater
Managing Editor: Tom Mugridge
Editor: Kylie Johnston
Art Directors: Tony Seddon and Julie Weir
Junior Designer: Jane Waterhouse
Designer: Andrew Milne

ILEX Research, Cambridge:
Development Art Director: Graham Davis
Technical Art Editor: Nicholas Rowland

British Library Cataloguing-in-Publication Data
A catalogue record for this book is available from
the British Library

ISBN 1-904705-69-3

Printed and bound in China

For more information on this title please visit:
www.web-linked.com/dcftuk

Projects using your digital camera, home computer, scanner, and printer

Creative Digital Crafts

HELEN BRADLEY

ILEX

Contents

Introduction 6

Getting Started
with Digital Crafts 8

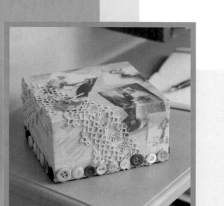

Decal Projects 22

✳ Child's Bicycle **24** ✳ Ceramic Dog Bowl **28**
✳ Child's Bedroom Window **32** ✳ Memory Box **36**
✳ Kitchen Clock **40** ✳ Decoupage Mirror **44** ✳ Model Train **48**
✳ Wedding Plaque **52**

Fabric Projects 56

✳ Appliqué Pillow **58** ✳ Christmas Banner **62** ✳ Angel Pillow **66**
✳ Doll's Dress **70** ✳ Kitchen Apron **74** ✳ Lavender Bag **78**
✳ Memory Quilt **82** ✳ Canvas Bag **86** ✳ Shoe Bag **90**

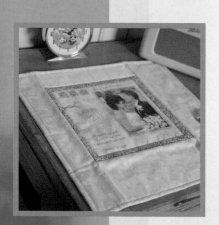

Novelty Paper Projects 94

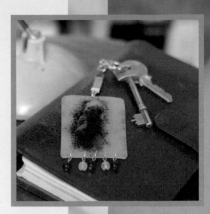

✳ Jigsaw Puzzle Picture Frame **96** ✳ Refrigerator Magnets **100**
✳ Heart-Shaped Earrings **104** ✳ Key Ring with Beaded Fringe **108**
✳ Portrait Badges **112**

Heat Transfer Projects 116

✳ Baby Bibs and Babygrows **118** ✳ Christmas Ornament **122**
✳ Cotton Apron **126** ✳ Pop Art T-Shirt **130**
✳ Chair Cover **134** ✳ Doll and Teddy Clothes **138**
✳ Sewing Basket **142** ✳ Roller Blind **146**

Appendix 150

✳ Further Resources **152** ✳ Glossary **154**
✳ Conversion Tables **156** ✳ Index **157**
✳ Acknowledgments **160**

Introduction

Welcome to *Creative Digital Crafts*. If you are like millions of people around the world today, you own a computer and digital camera, and you print photographs that you have imported from your scanner or downloaded from your camera. Since you have picked up this book and read beyond the first sentence, you also have an interest in crafts. There is no better combination of tools than a digital camera and a computer as a starting point to creating wonderful craft projects.

In this book I'll take you from the familiar tasks of taking photographs and downloading them to your computer, to preparing the photos using your computer software, to printing the images and then incorporating them into the designs of your craft projects.

You'll be surprised by the vast range of papers, plastics, and fabrics available for digital crafting. I've discovered a wide range of papers suited to producing beautiful effects. I'll show you how to take advantage of these using your home printer to create a number of appealing craft projects. Whether you love sewing, or you're interested in decoupage, or you want to create more handmade gifts this year, you'll find a crafting extravaganza of fun and easy-to-make projects in the pages of this book, all designed to inspire your own creativity.

Digital Crafts

Digital crafts are as old as computers themselves. It was considered high art when a Christmas card was illustrated with letters, numbers, and other characters that, when configured and appropriately spaced, resembled the image of Santa Claus. Times have changed. Now, when kids look at a Pop Art painting, they assume it was produced by a powerful printer!

At the same time as developments in computers, printers, and cameras have made it easier for us to produce images for use in our artwork, paper manufacturers have been creating new papers and printable materials for use with almost any home printer. For crafters, the digital age offers new possibilities and endless ways to combine technology and hands-on crafting.

About the Author

I have been writing books and articles about computers, photography, and crafts for many years, and they have been published worldwide. In 1999, my first digital craft book showed how to use Microsoft Word to create digital crafts, and the rest, as they say, is history.

For this book I've gathered together talented digital and handcraft designers who have lent their expertise to design these projects for you. More information on the artists can be found at the back of this book. (See page 160.)

Safe Practice

Whenever you are working on your crafts, always be careful to work safely. Read the warnings on all products and follow the manufacturer's guidelines exactly.

Keep all items that are not safe for young children, such as glues, paints, and sharp items, locked securely away when not in use. Always supervise small children when working with these items.

Getting Started

with Digital Crafts

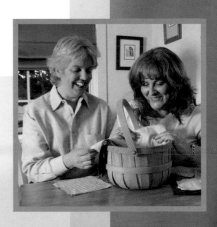

Setting Up a Workspace

Having a studio space or sewing room for crafting is a luxury that some of us have and some of us dream of having. Fortunately, none of the projects in this book require a lot of space to complete. At the very least, they can be made wherever a flat workspace and a heat-resistant surface are available.

If you have a space dedicated to crafts, furnish it with a solid countertop and shelves and cupboards to store craft tools and materials. Add a comfortable, ergonomic chair with correct lumbar support for health and ease of crafting.

You will also need a clean, clutterfree space for your computer and printer. A computer desk or workstation designed to house all your equipment is a good investment.

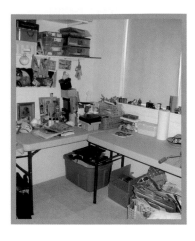

This is my workspace. Whether large or small, keep your space well-organized and comfortable.

Equipment

Chances are that you already have most of the equipment you'll need to complete the digital crafts found in this book. Here is a list of the basics.

Computer

While we have written this book using a PC running Microsoft Windows, the software, Adobe Photoshop Elements, is also available for the Macintosh. Your computer should be able to be connected to your digital camera or scanner for downloading and scanning photos, and to a printer so that you can print the artwork. Any computer purchased within the last three to four years should be suitable to produce the art used in this book.

You will be able to successfully perform all the same functions whether you use a PC or Mac.

Digital Camera

While a digital camera is not an essential tool, it's a great way to take photographs for use in your craft projects. If you don't have a digital camera, take photographs with a film camera, preferably an SLR with interchangeable lenses so that you can do close-up and macro work. Process the film, then scan the photos into your computer. Or, have a film-processing service put the photos on a CD so that you can manipulate the images using your computer, and then print them.

There is a wide range of SLR and compact digital cameras on the market, depending on your needs and your budget. Invest in as high-quality a camera as you can afford.

A good scanner offers you a vast range of possibilities for your crafts.

Adobe Photoshop Elements 3.0 is one choice of software for completing projects in this book.

Digital cameras are constantly evolving. What was a cutting-edge camera last year is this year's bargain. That said, most of the photos used in this book were shot with a 2-megapixel autofocus camera, now less advanced than the cutting-edge, 8-megapixel SLR. In short, you don't need an expensive camera to take great shots or to create wonderful crafts. Your camera should take photos that look good when printed on an A4 sheet of paper.

Scanner

While not technically required for the crafts in this book, a flatbed scanner opens up a wide range of crafting possibilities. You can scan objects such as paper, memorabilia, found and natural objects (for example, leaves and flowers, and office supplies) to make interesting images for use in craft projects. If you do not have a digital camera, a scanner is invaluable for scanning photographs.

A camera can also act as a substitute scanner. Thus, if you don't have a scanner, you can photograph images using your digital camera for use in your projects.

Graphics Software

While no specific software is required to complete these projects, we chose the Adobe Photoshop Elements 3.0 program for our instructions. Photoshop Elements is very popular. It comes free with many cameras and scanners, but if you buy it, it's reasonably priced. It is also easy to use and runs on both PCs and Macs, making it a good program of choice for the projects in this book.

If you're new to digital photo manipulation, you will find the step-by-step instructions invaluable for turning your photos into images for your projects. Each step is explained simply, and the knowledgeable Elements user will have no difficulty in completing each project. Most techniques are simple enough that anyone with basic computer skills should be able to perform them. One of the projects, the Kitchen Apron (see page 74), does require a higher level of skills, both for taking the photos and for manipulating them if a successful composite image is to be made.

If you're experienced with another program, such as Adobe Photoshop or Corel's Paint Shop Pro 9, these can also be used to complete the projects. Use the program's Help feature or its manual to learn how to perform any task in the step-by-step examples with which you are unfamiliar.

This book refers to Adobe Photoshop Elements 3.0 using the Windows operating system. The Macintosh version of this program uses similar commands for the same functions. Again, consult your program manual or help file for more information.

Printers

There are many types of printers on the market today, but the colour ink-jet printer is the one that's typically used by home-computer users.

An ink-jet printer works by spraying very small droplets of ink onto the paper surface. It is a particularly good printer to use for crafting applications because it is reasonably priced and the technology used to deliver the ink makes it equally useful for printing onto fabric and other special materials.

PHOTO PRINTER

Some of the ink-jet printers available on the market today are actually photo printers. These printers use six or more inks to produce vibrantly coloured photographs. While these printers are extremely useful for printing high-quality photos, they are not necessary for crafting applications. In many cases, depending on the media used, you will get as good a result using a standard ink-jet printer.

LASER PRINTER

A laser printer works similarly to a photocopier. It delivers the image to the paper using toner. The process of adhering the toner to the paper involves the application of heat to the paper. This makes a laser printer inappropriate for printing on papers or materials that distort or deform when they are heated. For example, you should never use shrink plastic in a laser printer. And, if you are using sticky labels, you should always make certain they are acceptable for use in a laser printer or you could damage the printer. Some manufacturers make T-shirt transfer paper that can be used with a laser printer.

There are other types of printers including dot matrix printers and printers that use thermal or solid ink technology. Because of their size, complexity, and price tag, these printers are more suited to the office environment than the home.

An ink-jet printer is an essential piece of equipment for your digital crafts. If you can invest in a photo printer, it will afford you photographic-quality images, but it is not necessary for digital crafts.

Printing Options

Many special papers require special printer settings for best results. When printing onto a special paper, check the manufacturer's instructions for any special printer settings required.

To configure your printer's paper settings, choose **File>Print** in your application and then click the Properties button or the Printer Properties button to open your printer's dialog. The printer dialog will vary according to the type of printer you own. However, each printer dialog will contain settings for paper and quality. You will need to set the size of the paper to that which you are using. In Europe the typical paper size is A4, which is 21.0 x 29.7cm. In the US this equates to Letter size, which is 21.59 x 27.94cm (8½ x 11in). Whichever size you are using, set your printer to that size.

From the Paper Type list, select the type of paper that you are using, such as Transparency or Photo paper. Avoid the temptation to select a different paper type, because each paper requires a different setting to optimize the printing qualities, such as the ability to absorb ink. If there is no entry for the type of paper that you are using, look for a setting such as Other Specialty Papers.

When you have selected the Paper Type, set the Print Quality. If you use a high-quality paper, such as Best, and find that there is too much ink on the paper, try again using Normal or Draft quality.

Use the Printer Properties dialog to select the correct paper size.

Select the correct Print Quality setting for the paper type you are using.

13

Craft Tools & Materials

Tools

Most of the projects in this book can be created using supplies that you might already have.

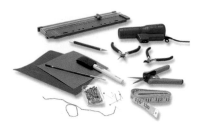

* Iron and ironing board
* Scissors – large and small
* Utility knife
* Paper trimmer
* Cutting mat
* Glues – including glues for paper and one-dimensional items
* Paintbrushes
* Sponges
* Pencils
* Ruler (preferably metal or with a metal edge)
* Tape measure

* 57mm (2¼in) diameter hole punch
* Wet/dry sandpaper
* Tweezers
* Nail file or emery board
* Needle-nose pliers
* Wire cutters
* Hand-sewing needle and thread
* Straight pins
* Small safety pins
* Embroidery needles
* Sewing machine
* Container for water

OPTIONAL EXTRAS

* Hot-glue gun (and glue sticks for adhering dimensional items)
* Rotary cutter (optional)
* 15 x 61cm (6 x 24in) rotary cutting ruler (optional)

You will need all kinds of equipment to complete your crafts, from straight pins, sewing needles, sandpaper, to paintbrushes, tape measures and an embossing heat gun (optional).

Some projects use special tools that are required for that project only. The Kitchen Clock (see page 40), for example, requires a hammer, large nail, and a metal drill bit to make a hole in the pizza pan, and the Heart-Shaped Earrings (see page 104) require an embossing heat gun.

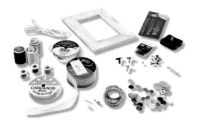

You will find it useful to create a toolbox for all your craft accessories in which to keep your selection, including buttons, brooch clips, metal frame corners, clock hands, wooden picture frames, ribbon, cord, picture hooks and pins, wire, and threads.

Materials

The projects have been designed to use materials that are easy to find and purchase. Most reputable craft stores and chains carry most of the items used in this book. Stores specializing in cookware and hardware can provide more. The Internet is an invaluable source of any materials or craft items you can imagine.

If you sew or quilt, you probably have a selection of fabrics on hand that can be used. If you make jewellery, you may already have head pins and findings and other jewellery supplies.

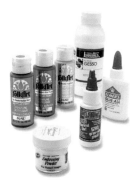

To bind and decorate your craft projects, you will need a selection of coloured craft paints, embossing powder, acrylic gesso, and glues.

Some of the projects use household items, such as a roller blind, pizza pan, and dog bowl, while others use special items, such as embossing powder, craft paints, and clock movements. The list of materials accompanying each project details the required items.

Source Material

Clip Art

Some projects use clip art instead of photographs. Clip art refers to illustrations created and saved as files on your computer. Clip-art images come free with many programs, but clip-art collections can also be purchased.

If you purchase a clip-art collection, the disk will probably include instructions on accessing the art. In most circumstances, you can simply open the clip-art image in your software in much the same way as you would open a photograph.

The Internet is a great source of clip-art images. Many sites offer free clip art that can be downloaded and used in your software. However, much of the art displayed on the Internet is protected. Only use it with permission. Do not use one that has been downloaded from a website in your craft projects. Doing so could be a breach of copyright.

Much of the clip art used in this book has been drawn by project designer Michelle Shefveland. Her website, cottagearts.net, contains many more templates and images for your use.

Fonts

In addition to clip art, a selection of fonts will be needed for your text. Like clip art, fonts are readily available on the Internet and there are many sites for free downloadable fonts. You'll find some of these listed in the Further Resources section of the book (see page 152).

Fonts must be installed on your computer if they are to be used. When you have downloaded the font file, you must uncompress the file if it is stored in a compressed format and then install the fonts by using the fonts tool in the Control Panel of your computer. Once a font is installed in Windows or on your Mac, it will be available to all programs on your computer. Having a range of fancy fonts as well as a range of clip art means that you'll never be short of a picture to use for your crafting projects.

Cottagearts.net is one of a number of excellent suppliers of clip art and ready-made templates that you can use as part of your photographic craft projects.

This font works well with the cute theme of this ceramic dog bowl project.

Photographs

One of your best sources of images for computer crafts is your own collection of family photos. These photos can be downloaded from your digital camera to your computer. In some cases, you may take photographs for use in a particular project. It is always a good idea to take multiple images so that you can choose the best one.

To download photos from your camera, connect the camera to the computer using the appropriate cable or remove the card and place it in a card reader. Follow the instructions in your camera manual when downloading images from your camera or camera card to your computer. Take care that you do not risk damaging the camera card and the images on it.

Make note of where your photos have been copied so that you can find them later on. When using photographs for digital crafts, make sure that you use a copy of the photograph and not the original file. To make a copy, open the file in your graphics software, choose **File>Save As**, and save the image with a new name. Close the image, then open the copy you've just made – this is a critical step towards protecting the original.

Use photos of your family and friends as inspiration for your projects. They can also be used to make personalized gifts.

Printable Materials

Throughout this book we have concentrated on giving you the broadest possible introduction to a wide range of printable craft materials. As you become more familiar with digital crafts, you'll find yourself collecting different types of paper and fabric for future crafting opportunities. In my crafting toolkit are sheets of printable ink-jet shrink plastic, canvas, silk, and T-shirt transfer paper for both white and coloured T-shirts, decal paper, and fabric-backed carrier paper.

Taking multiple images of one subject can be very useful when you want to pick more than one image for a project.

Remember to keep the instruction sheets that come with the papers. Each brand and type of paper has its own set of recommended printer settings as well as instructions if it is to adhere to your projects. Often, directions for washing are important in caring for and maintaining the finished project.

Decals

Decals are made of a synthetic material that can be printed on. When the printed image is soaked in water, the backing paper can be peeled away and the image can be applied to a surface. There are a number of decal products available. One of these, Lasertran ink-jet decal paper, can be made transparent when oil-based varnish is applied. Without this varnish step, the decal is only partially transparent. We have included projects that use both opaque and transparent decals.

The projects in this book introduce you to a wide range of printable fabrics and papers.

Printable Fabric

There is a wide range of printable fabric available that can be printed on using an ink-jet printer. While quilting afficionados have known about this material for years, general crafters are just discovering it. We have discovered a variety of different printable fabrics, including silk, to use in our fabric projects. Many of these fabrics are interchangeable, but be certain to read the manufacturer's instructions before applying images to their surface.

It's also possible to print on almost any fabric using an ink-jet printer and fabric carrier paper. This special paper adheres to the back of the fabric, making it sturdy enough to pass through an ink-jet printer without buckling. We have included two projects using fabric carrier paper so that you can experiment with it. This paper can be interchanged with regular ink-jet-printable fabric should you wish to make the switch.

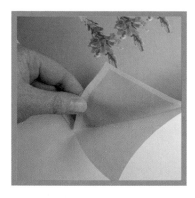

Silk is a lustrous fabric that can be easily transformed into works of art with the aid of your printer.

Novelty Paper

Novelty papers are fun to work with. We've used special jigsaw puzzle paper to create our Jigsaw Puzzle Picture Frame (see page 96). Our Refrigerator Magnets (see page 100) are made from special magnetic paper that can be printed onto and be adhered to any metal surface.

For the Key Ring with Beaded Fringe (see page 108), we used shrink plastic. This amazing printable plastic is flexible before it is heated, but shrinks to a fraction of its original size and becomes very resilient when heated in a regular oven. Colours printed onto shrink plastic also become more vibrant after the plastic image shrinks. Our Portrait Badges (see page 112) utilize vellum and office transparencies, and the Earrings (see page 104) use embossing paper on which the ink dries very slowly, allowing it to hold a layer of embossing powder that melts to a shiny coating when heated.

Jigsaw puzzle paper is great fun to use and simple to adapt to all kinds of projects.

Heat Transfer Paper

There are a range of papers on which images are printed and then adhered to another surface using heat. Some of these papers are advertised as T-shirt transfer papers, but their use need not be limited to T-shirts, as you will see. We used these papers on babywear (see page 118), pillow covers (see page 134), and an apron (see page 126). The papers come in special opaque versions that can be adhered to coloured fabrics. There is also a glow-in-the-dark version that really works!

Other heat transfer papers work when heat is applied, melting the adhesive on the paper so it can then be adhered to another surface. If you are unable to locate any of these papers in your local craft or stationery store, consult the list of online resources (see page 152) to order them.

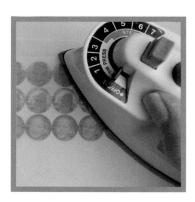

Heat transfer paper can be used for all kinds of projects – the only limit is your imagination.

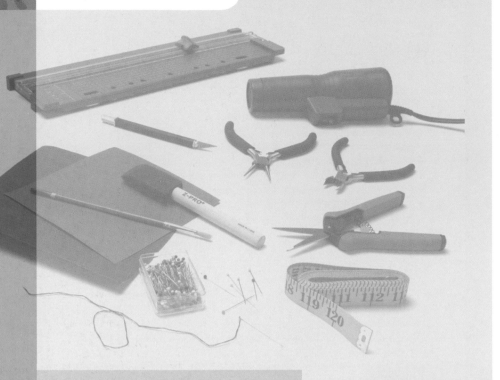

Creative Digital Crafts explores all kinds of crafting techniques – everything from sewing and gluing to heating transfers and fitting clock movements.

Crafting Techniques

While all the projects use the computer to prepare and print digital images, the actual projects they decorate are very different. The projects cover a range of crafting techniques and different levels of crafting skills.

Gluing

One of the featured crafting techniques includes decoupage, which involves cutting and gluing printed images on various objects. In the Memory Box project (see page 36), the principles of decoupage are applied to the use of decal images in combination with the use of a hot gun that adheres three-dimensional items to decorate the box.

Decals are also used to decorate china and windows, in addition to being adhered to painted wood surfaces and a child's bicycle (see page 24). Decals are either the peel-and-stick variety, or Waterslide decals whose backing slides off when wet, allowing the decal to adhere to a surface when dry.

There are numerous types of decal available that can be used to decorate your projects.

Sewing

The sewing projects vary in skill level, from the Christmas Banner (see page 62) and Angel Pillow (see page 66), to a Memory Quilt (see page 82) and a Chair Cover (see page 134). While we recommend a sewing machine for expediency, any of the featured projects can be hand-sewn. In some cases, the image is adhered to the sewn project as a final step – for example, the Shoe Bag (see page 90) and the Sewing Basket (see page 142). In other cases, such as the Lavender Bag (see page 78), the fabric is first printed and then used to make the item.

Use a sewing machine to stitch the Memory Quilt project (see page 82), but for other projects consider sewing by hand.

Heating

Some projects utilize special craft materials, such as embossing powder (see the Earrings project, page 104). When heated, this special powder melts, and, as it cools, it sets to a shiny, clear surface. A special embossing heat gun, available in the rubber stamp area of the craft store, is needed to melt the embossing powder. Other special papers used include jigsaw puzzle paper, vellum, and transparencies. We've given each of these materials a new twist and found creative new ways to use them. One project uses shrink plastic (see page 108), which shrinks to a fraction of its size when heated in a household oven. It is one of the most fun materials to use.

Other projects are made using a household iron. In some cases, the iron is used to affix the finished images to an item. The T-shirt transfer project (see page 130), for example, is created by ironing the completed image onto a T-shirt. Projects such as these are a good introduction to crafts if you are a relative beginner, because they are easy and quick to make. In other projects, the iron is used to melt adhesive so an image sticks to your project. The Christmas Ornament (see page 122) uses this technique.

The Pop Art T-shirt project (see page 130) demonstrates how easy it is to use heat transfer papers.

Brushing and Sponging

Some of our projects involve brushing or sponging paint onto an object. The wonderful thing about paint is that it can be used to resurface an existing item or to transform raw wood into an item that coordinates with your decor. We used acrylic paints in squeeze bottles. They are inexpensive and clean up easily with soap and water. Once you've painted your first wooden frame, you'll know how easy it is and what wonderful results can be achieved using paint.

Sponging layers of different-coloured paints onto your project can really add depth to its appearance.

Skill Levels

The list of projects in the table, opposite, recommends the approximate level of skill required to complete them.

The projects encompass a range of methods and techniques, producing everything from wearable projects to home decoration. If properly supervised, children can complete or help with most of the projects. However, in all cases, children should not be left alone when working with the tools, materials, and techniques featured in this book.

Mix and Match

Many projects are mix-and-match – for example, if you love the design for the kitchen apron, you can easily adapt this to an iron-on transfer project or use it on a pillow or a key ring. I'm confident that you will be so inspired by these designs and projects that you'll find lots of uses for the photographs you take with your digital camera. You'll probably also be inspired to take photographs especially for the projects, and you'll have as much fun planning the photos as you do in completing the crafts.

Working on projects with your children is fun, but always ensure that they are supervised when completing projects in this book.

You can adapt your digital photography and printing to all kinds of exciting projects for you and your friends.

	PROJECT	PAGE	TECHNIQUE	COMPUTER SKILL LEVEL	CRAFT SKILL LEVEL
1	Child's Bicycle	24	Decoupage using decal	INTERMEDIATE	BASIC
2	Ceramic Dog Bowl	28	Decoupage using Waterslide decal	INTERMEDIATE	BASIC
3	Child's Bedroom Window	32	Decoupage using decal	BASIC	BASIC
4	Memory Box	36	Decoupage using Waterslide decal	BASIC	INTERMEDIATE
5	Kitchen Clock	40	Decoupage using Waterslide decal	BASIC	INTERMEDIATE
6	Decoupage Mirror	44	Decoupage using Waterslide decal	BASIC	INTERMEDIATE
7	Model Train	48	Decoupage using decal	BASIC	BASIC
8	Wedding Plaque	52	Decoupage using Waterslide decal	BASIC	BASIC
9	Appliqué Pillow	58	Printable cotton fabric	INTERMEDIATE	INTERMEDIATE
10	Christmas Banner	62	Printable cotton fabric	BASIC	BASIC
11	Angel Pillow	66	Printable silk fabric	BASIC	INTERMEDIATE
12	Doll's Dress	70	Printable paper-backed fabric carrier	INTERMEDIATE	INTERMEDIATE
13	Kitchen Apron	74	Printable adhesive fabric	ADVANCED	BASIC
14	Lavender Bag	78	Printable silk fabric	ADVANCED	INTERMEDIATE
15	Memory Quilt	82	Printable paper-backed fabric carrier	INTERMEDIATE	INTERMEDIATE
16	Canvas Bag	86	Printable adhesive fabric	BASIC	BASIC
17	Shoe Bag	90	Printable adhesive fabric	INTERMEDIATE	INTERMEDIATE
18	Jigsaw Puzzle Picture Frame	96	Printable puzzle paper	BASIC	INTERMEDIATE
19	Refrigerator Magnets	100	Printable magnetic paper	INTERMEDIATE	BASIC
20	Heart-Shaped Earrings	104	Printable embossing paper	BASIC	INTERMEDIATE
21	Key Ring with Beaded Fringe	108	Printable shrink plastic	INTERMEDIATE	INTERMEDIATE
22	Portrait Badges	112	Printable vellum and transparencies	INTERMEDIATE	INTERMEDIATE
23	Baby Bibs and Bodysuits	118	Printable coloured fabric T-shirt transfer paper	INTERMEDIATE	BASIC
24	Christmas Ornament	122	Printable ink-jet adhesive paper	BASIC	INTERMEDIATE
25	Cotton Apron	126	Printable coloured fabric T-shirt transfer paper	BASIC	BASIC
26	Pop Art T-Shirt	130	Printable glow-in-the-dark T-shirt transfer paper	INTERMEDIATE	BASIC
27	Chair Cover	134	Printable T-shirt transfer paper	BASIC	ADVANCED
28	Dolls' and Teddy Clothes	138	Printable T-shirt transfer paper	INTERMEDIATE	BASIC
29	Sewing Basket	142	Printable T-shirt transfer	INTERMEDIATE	INTERMEDIATE
30	Roller Blind	146	Printable ink-jet adhesive paper	BASIC	BASIC

Decal
Projects

✳ Child's Bicycle **24**

✳ Ceramic Dog Bowl **28**

✳ Child's Bedroom Window **32**

✳ Memory Box **36**

✳ Kitchen Clock **40**

✳ Decoupage Mirror **44**

✳ Model Train **48**

✳ Wedding Plaque **52**

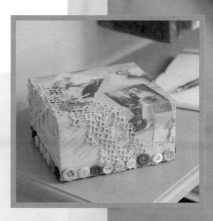

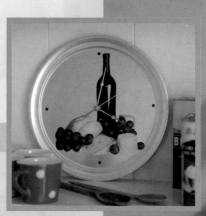

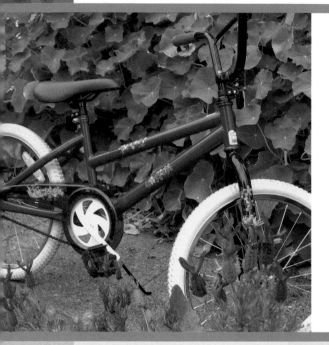

Child's Bicycle

Every child's bicycle is subject to heavy wear and tear – and that is to be expected. But if you want to give the bicycle a new look or to make it good as new again, this is the project for you. All you need is some Waterslide decal paper, a sunny afternoon, and a little patience, and you can transform a child's bicycle into a gleaming mode of transport.

Materials

* 2 or 3 sheets of Waterslide decal paper
* Child's bicycle
* Water-based varnish

Tools

* Scissors
* Container for water
* Soft, lint-free cloth, or paper towels
* Paintbrush

1 Launch your software and create a new document by choosing **File>New>Blank File** and configure it to 21.59 x 27.94cm (8½ x 11in) in size, 300ppi, and with a White background.

2 Add a new layer to the image using **Layer>New Layer**. Select a Foreground colour for the flower and use the Paintbucket tool to fill the layer.

3 Click the Cookie Cutter tool and select the Shape drop-down list. From the right of the list, click the arrow to open the menu, choose the Shapes collection, and click the Blob 2 shape. On the toolbar, disable the Crop checkbox and drag the shape onto the coloured layer. Press enter to cut out a small, coloured flower.

4 Click the Elliptical Marquee tool and hold the Shift key as you draw a circle for the middle of the flower. If you need to move the circle as you draw it, hold the Space bar, move the circle, and then let go of the Space bar to continue to draw it.

5 Select a different Foreground colour for the centre of the flower. Click the Paintbucket tool, and then click on the selection to fill the centre of the flower.

6 To make more flowers from the first one, right-click the layer with the flower on it, choose Duplicate Layer, and click OK when the Duplicate Layer dialog appears. Use the Move tool to move the flower to a new position, size it larger or smaller, and rotate it slightly.

7 Repeat steps 2–6 to create more flowers. Arrange these in groups – these will go on the bars of the bike. To vary the overlap of the flowers, drag the layers containing the flowers up or down the Layer palette.

8 To add your child's name over the top of a flower pattern, click the Text tool and choose a font and font size. Select the font colour. Type the child's name – for the project shown here, we used a free 1960s-style font called Action Is Shaded, which is available from www.getfreefonts.com/fonts/26.html.

9 Click the Type layer, choose **Layer>Type>Warp**, and, from the Style list, choose a Warp style. Then configure the other options until you have a look you like. Click OK.

10 If you want to use an outline font, fill the interiors with colour. Select a new Foreground colour, click on the Paintbucket tool, and then click on the type in an interior area to fill it. If a prompt appears to Simplify, click OK.

11 If desired, repeat the type effect and continue until you have sufficient elements.

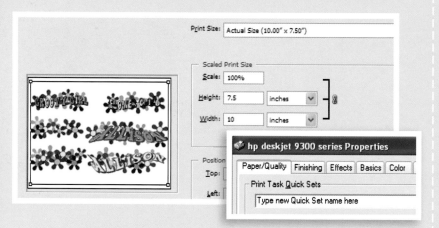

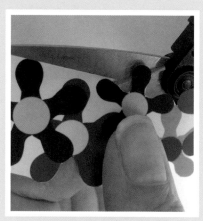

12 To print, choose **File>Print** and then Page Setup. Set the Print Size in the Print Preview dialog to Actual Size. Set the Orientation to Landscape, and click Printer and then Properties to set the Paper Type and the Print Quality to match those suggested by the paper manufacturer. Click Print and print two copies of the image. Allow to dry for a least an hour or as recommended by the manufacturer.

13 Use scissors to cut around the flowers on the printed page to create a series of strips that can be adhered to the bicycle frame.

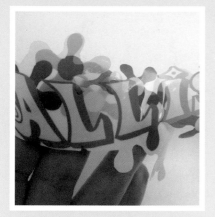

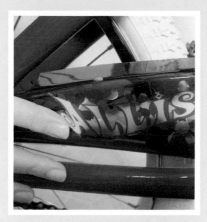

Tips

✱ WATERSLIDE DECALS

Decal paper is a special kind of transparent craft paper that is easy to print onto. Here, you use Waterslide decals, which, once printed and dried, are soaked in water to remove the backing paper, making it ready to adhere to almost any object.

14 Fill the container with water. Place the cutouts, one at a time, in the water bath for the time specified by the manufacturer, and then remove from the water. Slip the image from its backing paper.

15 Adhere the shape to the bicycle frame and smooth any wrinkles. Blot the extra moisture with a soft, lint-free cloth or damp paper towel. The decals will be transparent when first adhered, but they will become opaque as they dry.

Ticket to ride

Of course, this project can easily be adapted for a boy's bicycle, too – just select a different-style decal for the look you choose.

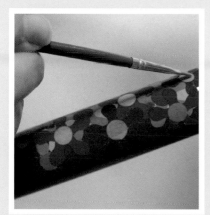

16 Repeat with the other cutouts. When dry, apply a water-based varnish to the flowers and the surrounding bicycle frame to seal them. This will give the decals some resilience against wear and tear and some resistance to moisture.

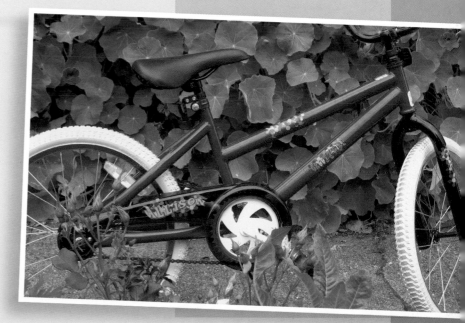

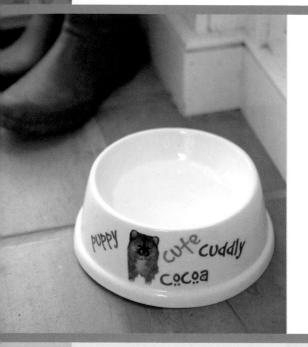

Ceramic Dog Bowl

For this project, we added decals to a dog bowl to make this cute, one-of-a-kind dish that any pooch would be proud to call his own. Of course, the same technique can be used to create a unique bowl for the feline in your life. The decoration was made using Waterslide decal paper. The decal paper is printed with an image, then moistened with water. Once wet, the backing paper slides away, leaving behind the image layer. The image can then be affixed to the surface of a range of household objects.

* Photo of dog or cat in digital format
* 1 sheet of Waterslide decal paper for ink-jet printers
* White or light-coloured dog or cat bowl
* Oil-based varnish

* Small scissors
* Large container for water
* Damp sponge
* Paintbrush

1 Open your dog or cat image and make a rough selection around the perimeter of the shot. An image that shows the animal's entire form with a clear outline works best for making a cutout. Don't worry too much about the fur right now.

2 Choose **Select>Feather** and add a Feather value of 3 to the selection. Choose **Select>Inverse** to invert the selection. Set the Background colour to White and press Delete to remove the background.

3 Turn off the selection by choosing **Select>Deselect**. Click the Brush tool and, from the Brushes palette, choose a chalk brush or one with spiked ends. To replace the image background with white and to create a textured edge, set the Foreground and Background colours to White and paint along the edges of the pet's hair, following the natural growth lines.

4 To change the brush direction, open the Brush Preset Picker and choose More Options. At the bottom of the dialog, rotate the brush to a new angle. This allows you to work on both sides of the animal.

5 When you're finished with the image, create a new document, about 1000 x 500ppi in size. Sample a Foreground colour from your pet's coat using the Eyedropper tool. Type your pet's name and an additional word or two if desired.

6 To make a paw print, create a new document, this time 500 x 500ppi in size, and fill with your desired colour. Click the Cookie Cutter tool, click the Shape drop-down palette, and then the small arrow that opens the Shape menu. Click the Animals option. Select the Paw Print 2 shape in the Shapes palette.

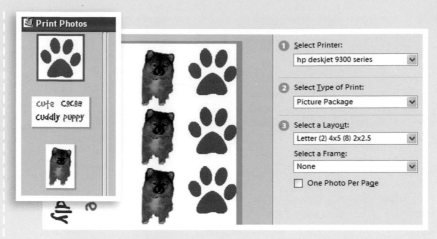

7 Drag the paw shape onto the image and size to fit. Make sure that the Background colour is White and press Enter to cut a paw print from the brown background.

8 Choose **File>Print Multiple Photos** and, from the Select Type of Print list, choose Picture Package. Choose a layout such as Letter (2) 4 x 5 (8) 2 x 2.5. Drag and drop the images into the boxes on the page. We used the larger box for the words. Print the image onto the paper. Allow to dry for the recommended time.

9 Using a small pair of scissors, cut carefully around the images and then place loosely onto the cat or dog bowl to plan your layout.

10 Fill the container with water. Working with one decal at a time, submerge each cut-out decal in the water. Let soak for 15 seconds (or the length of time recommended by the manufacturer), then remove from the water.

11 Carefully slide the image from the backing sheet. Discard the backing paper. Position and press the image onto the dog or cat bowl, as desired.

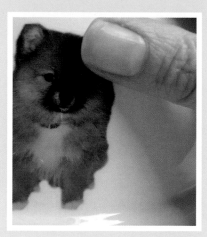

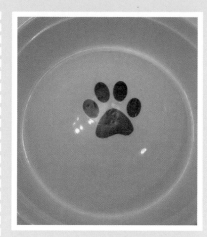

✳ **USE A GREAT FONT**

The font used for this project is called Good Dog Cool. It is freely available for download on the Internet. Some of the letters in the font, such as the letters h, k, o, n, x, v, and g, have interesting additions, which make the font particularly suitable for projects involving cats and dogs.

12 Use a wet finger to smooth out any air bubbles. Use a damp sponge to soak up any excess moisture.

13 Position and press the remaining decals onto the bowl as before. If desired, turn the bowl over and place a paw print decal on the underside. Set aside to dry thoroughly.

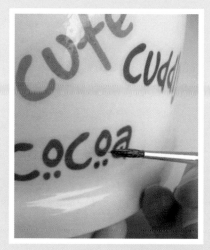

14 To protect the decals, varnish with a suitable varnish. If you use Lazertran paper and an oil-based varnish, the decals will become translucent so that the edges are not so visible.

It's chow time!

Cat or dog, your pet will love to eat from this delightful ceramic bowl.

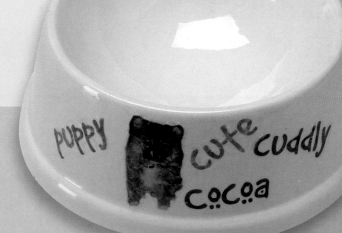

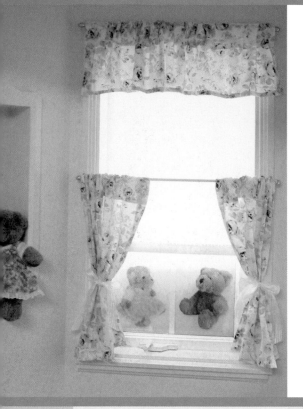

Child's Bedroom Window

What could be more fun than putting a photo of a child's favourite bear on his or her bedroom window? It's easy to do using window cling, a special kind of material that can be printed on and then adhered to a window. It's removable, so it is ideal if you wish to replace it with a different image. Complete this project and you'll know how to use window cling to produce great decorative effects in the home.

Materials

* 2 plush bears or toys, as desired
* 2 sheets of clear window cling

Tools

* Window cleaner
* Paper towels

1 Position one bear at a time on a flat surface, making sure the background colour is light and contrasts with the colour of the bear's plush coat. Take a few close-up portraits of each bear, using the macro setting on your camera for the best results. Use different orientations for each bear. For example, photograph one bear facing left and the other facing right.

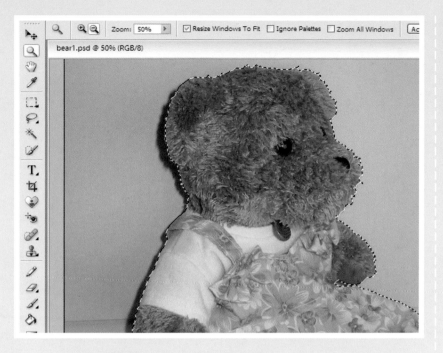

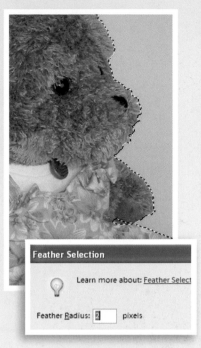

2 Open up the first photo in your software and use the selection tools to make a selection around the bear. The Magic Wand tool or Magnetic Lasso are good for this job.

3 Once the selection is made, choose **Select>Feather** and set a feather of 2 or 3 pixels. This softens the edge of the selection.

4 To silhouette the bear, set the Background colour of the photo to White and choose **Select>Inverse**. Press Delete to remove the background. This will make it white. Because white won't print, all that will be visible on the paper when the image is printed is the bear.

5 Choose **Select>Deselect**. Use the Crop tool to crop closely around the bear so that it takes up all the available space on the paper.

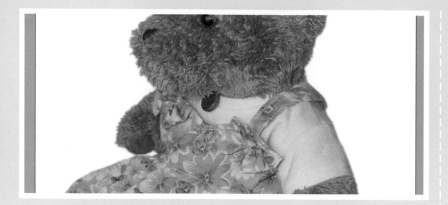

Tips

※ USING DECALS
 TO MAKE YOUR
 WINDOW PRIVATE

If a child's bedroom window is visible from the street, paint the inside of the window with faux-stained glass paint or the white paint sold for decorating glass for Christmas. Then apply the decals over the top of the paint to create a decorative window covering.

6 If you plan to adhere the image to the outside of a chosen window so that the image shows through to the other side, you must reverse the image using **Image>Rotate>Flip Horizontal** on your computer. However, for this project it's not necessary.

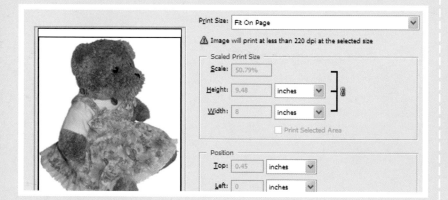

7 To print the images, click one image to select it and choose **File>Print**. From the Print Size list, choose Fit on Page. Select Print, choose Properties, and set the Paper Type and the Image Quality recommended by the manufacturer of the window cling.

8 Place the window cling in the printer, taking care to ensure that it will print on the correct side of the material. Print the image. Repeat this to print the second bear. Allow both sheets of window cling to dry thoroughly – a minimum of 20 minutes – before continuing.

 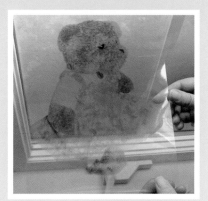 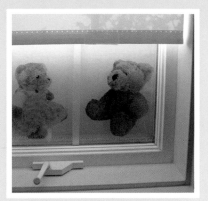

9 Use glass cleaner and paper towels to clean the window thoroughly before adhering the images.

10 Place the right-facing bear on the left side of the window by peeling off the backing paper from the window cling. Position and press the top edge of the sheet to adhere, allowing gravity to draw the rest of the sheet into place against the window.

11 Repeat step 10 to position and adhere the second bear on the opposite side of the window so that it faces the first bear.

Tips

✳ CLEANING THE WINDOW

Avoid rubbing alcohol to clean the window. While it successfully removes fingerprints and other oils from the surface, it makes adhering decals difficult.

Bear necessity

This charming bear image will beautifully enliven the window in a child's bedroom. Consider adding several more to the arrangement, making them smaller sizes for variety.

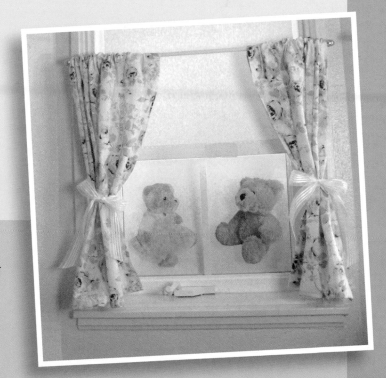

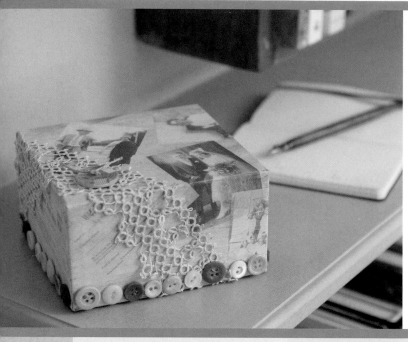

Memory Box

Very often, a cherished item such as a special photograph, a pebble from a day at the beach, cinema ticket stub, a baby's first shoe, or a pressed flower from a country walk remain at the bottom of a drawer or hidden away somewhere. Making a memory box is a creative alternative to storing and displaying your treasured three-dimensional objects and other sentimental mementos.

* Vintage photos and memorabilia in digital format
* 1 sheet of Waterslide decal paper for ink-jet printers
* Sturdy gift or papier-maché box, size as desired
* Antique white acrylic craft paint
* Antiquing medium
* Craft glue
* Clear varnish (optional)
* Lace
* Buttons without shanks

* 2 paintbrushes, 2.5cm (1in) and 5mm (¼in) wide
* Soft, lint-free cloth, and sponge
* Pair of scissors or paper trimmer
* Container for water
* Hot-glue gun and glue sticks

1 Open the selection of digital images you'd like to use to decorate your box. We opened six different vintage images.

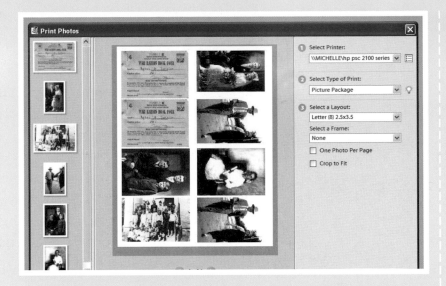

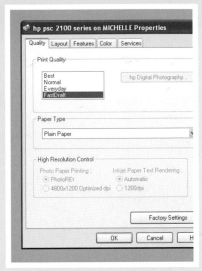

2 Choose **File>Print Multiple Photos** and, from the Select Type of Print list, choose Picture Package. Choose a layout such as Letter (8) 2 x 2.5. Drag and drop the images into the boxes on the page. If desired, duplicate some to fill the page.

3 Set Print Settings to Plain Paper type and Draft quality so that you do not apply too much ink to the decals.

4 Print the image onto the creamy side of the decal paper. Let the ink dry as recommended by the manufacturer.

5 To prepare the box, use a brush to apply one or two smooth coats of white paint. Let the paint dry between coats. Use a cloth to apply a thin coat of antiquing medium to all exterior surfaces of the box. Quickly wipe off with a damp, clean cloth for an aged patina. Let medium dry.

Tips

✳ USING WATERSLIDE DECAL PAPER

For this memory or keepsake box, we used Lazertran Waterslide decal paper for ink-jet printers. This paper doesn't need to be sprayed with a sealer like other ink-jet Waterslide decals. The inks become waterproof after 30 minutes' drying time. When dry, the decal can be immersed in water without washing away the colours. The eggshell white decal can be made transparent and sealed by applying a thin coat of oil-based varnish such as polyurethane.

6 To prepare the decals, use scissors or a paper trimmer to carefully cut around the perimeter of each image printed on the decal paper.

7 Prepare a shallow water bath and position it close at hand so that you can work quickly. Immerse the decal in water until the backing paper lifts away from the decal.

8 Carefully lift the decal from the water, slide away the backing paper and discard. Position and press the decal onto the box, making sure to remove any air bubbles. Smooth the image until it adheres completely, wrapping around edges and corners as desired, using a damp cloth or sponge. Repeat for all the decals and set the box aside to dry.

9 To ensure that overlapping decals adhere properly, apply a dab of craft glue to the edges of decals where necessary. To add a protective finish, use a clean, 2.5cm (1in) wide brush to apply a thin coat of clear varnish.

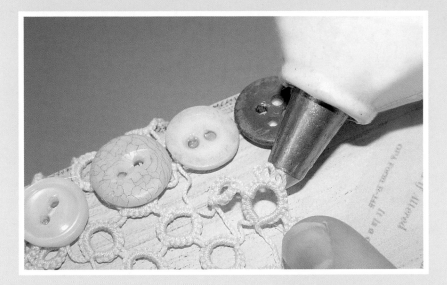

Tips

❋ SCANNING
 MEMORABILIA

To scan memorabilia for this project, scan a marriage certificate, for example, for print reproduction at around 200dpi (but not Screen, which is too low a resolution). Print the image at an appropriate size for your memory box. Scanned images don't have to be printed at full size, and they often look great printed at one-half or one-quarter size.

10 To apply decoration, position each element, one at a time, in place on the box as pictured, or as desired, using a dab of glue from a hot-glue gun to secure. Be careful when securing the decoration, as both the glue and gun are hot enough to cause burns.

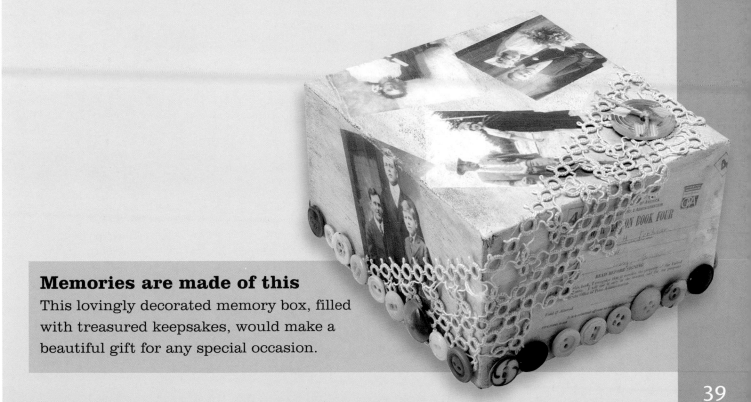

Memories are made of this

This lovingly decorated memory box, filled with treasured keepsakes, would make a beautiful gift for any special occasion.

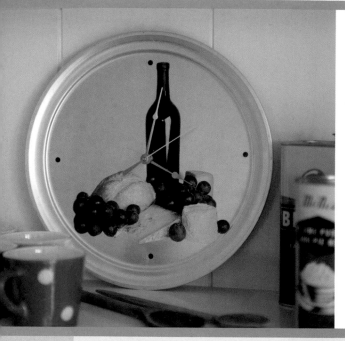

Kitchen Clock

This project shows that you can make something truly original from materials that might, at first, seem a little eccentric. The pizza pan used to make this kitchen clock was an inspired choice – it is just the right shape, size, and finish for the effect we wanted to achieve. All you need is a little bit of confidence using a drill to make the hole in the centre, and the imagination and flair to match the design to your decor. The parts, such as the clock movement, are easy to source from craft suppliers.

* Still-life image
* 1 pizza pan, approximately 30cm (12in) in diameter
* Quartz clock movement
* Clock hands
* 1 sheet of Waterslide decal paper

* Small, soft sponge or paper towel
* Container for water
* Pencil and ruler
* Tape measure and chalk
* Hammer and large nail
* Drill and drill bit for metal
* Scissors
* Safety glasses
* Small block of wood
* Clamps
* Soft cloths
* Tweezers
* 5mm (¼in) hole punch

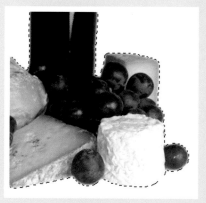

1 Go to the download site (http-design.com) and select this image. Alternatively, create your own. To set up your own still life, assemble breads, cheeses, grapes, and a bottle of wine and arrange them in a pleasing way in front of a neutral background. Photograph the arrangement and open up the image in your software.

2 Use the selection tools to make a selection around the objects. Choose **Select>Feather** and apply a 3-pixel feature to the image. Select a White background, then choose **Select>Inverse** to invert the selection. Press Delete to remove the background. Choose **Select>Deselect**.

3 Use the Rectangular Marquee tool and a black (or dark) Foreground colour to draw a small square in the area that you just removed. Fill the square with the colour. This colour will be used to create time markers on the clock.

4 Print the still-life image onto the decal paper using the settings recommended by the manufacturer. For this project, Plain Paper and a Normal print setting were used. Print the image large so that the image is in proportion to the dimensions of the pan. Dry for at least half an hour.

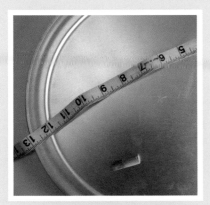

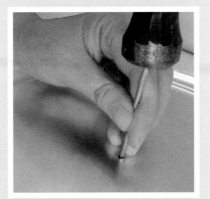

5 To locate the centre of the pan, use a tape measure and chalk as follows. On the front of the pizza pan, lay the tape across the pan, positioning the ends at the widest points, and mark a 2.5cm (1in) line as near to the centre as possible. Rotate the pan and repeat twice. The centre of the pan is located at the point of all three intersecting lines.

6 Put on safety glasses. To make a centre pilot hole in the pan, place a small block of wood under the pan. To punch a small pilot hole in the centre of the pan, position the point of the large nail at the marked centre and use a hammer to pierce the pan.

7 Use clamps and protective soft cloths to secure the plate to a flat surface. The size of the drill bit you'll need can be determined by the width of the shank of the clock mechanism. To drill the hole, attach a metal drill bit to the drill. Drill a hole through the marked centre of the pan.

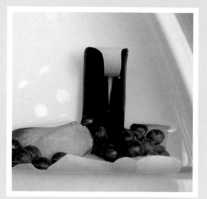

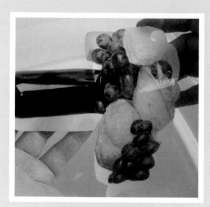

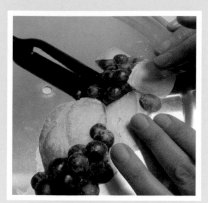

8 To prepare the image, use scissors to cut around the perimeter of the image on the decal paper. Prepare a shallow water bath and position it close at hand so that you can work quickly. Immerse the decal in the water until the backing paper begins to lift away from the decal.

9 Lift the decal from the water and carefully slide off the entire backing paper from the decal. Discard the backing paper.

10 To decorate the pan, position and carefully press on the pizza pan. To work out any air bubbles between the decal and the surface of the pan, use wet fingers to smooth out the decal, working from the centre to the edges.

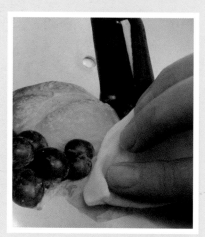

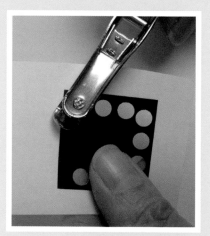

11 To finish, use a damp sponge or paper towels to gently smooth the image onto the pan and to absorb excess moisture. Set aside to dry.

12 Lay the pan on a flat surface in a vertical orientation. To mark the hours, use a ruler to mark the positions for 3, 6, 9, and 12 – approximately 3.8cm (1½in) in from the edge, beginning with the 12 position.

13 To prepare the hour markers, use a 5mm (¼in) hole punch to make five dots from the sheet of decal paper with the black square.

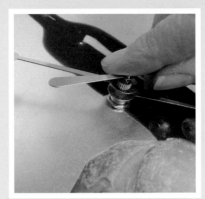

Tips

✳ DECORATING THE CLOCK FACE

Waterslide decal paper is extremely adaptable. You can print an image onto it, and then wet it so that the backing paper slips off easily, leaving a flexible adhesive film. This film can be adhered to any surface. Here, we have used a still life of an Italian-style picnic with wine and cheeses to decorate a fanciful kitchen clock made from a pizza pan. The opacity of the paper ensures a clear image when affixed to a metal surface.

14 To prepare the decal dots, immerse them, one at a time, in the water bath for 15 seconds. Use tweezers to remove from the water, and carefully slide the backing paper away using your fingers. Affix two dots on either side of the marker at the 12 position and one dot over the markers for the numbers 3, 6, and 9.

15 Assemble and fix the clock mechanism onto the pizza pan following the manufacturer's instructions. This will involve passing the shank of the clock through the hole and fixing it in place with a nut. Screw on the hands as instructed and push the second hand onto the mechanism to finish.

Time piece

Once finished, mount the clock to your kitchen wall. Whenever you check the time, you can admire your work!

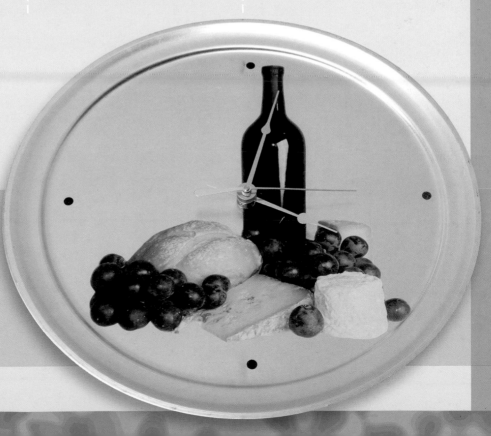

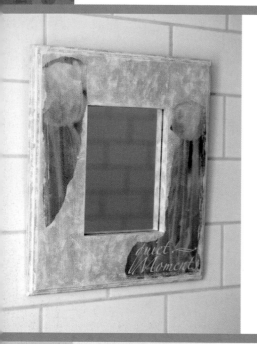

Decoupage Mirror

Mirror and picture frames make ideal beginnings for creating original furnishings for your home. Here, a raw wood frame was decorated using Waterslide decals in a floral motif. First the frame was painted a colour that matched the paper, and then a sheet of decals was added, creating a very special frame for a mirror. The benefit of Waterslide decal paper is that it adheres to most surfaces. Its opacity keeps the image from blending in with the background.

Materials

* Photo or other image in digital format, or use the featured image from the download site
* 1 sheet of Waterslide decal paper for ink-jet printers
* Raw wood frame with wide sides
* Artists' gesso
* Acrylic paint in light green, pink, cream, and white

Tools

* 320-grit wet/dry sandpaper (or similar)
* Container for water
* Soft, lint-free cloths
* Paintbrushes
* 3 sponges
* Mirror to fit frame
* Double-sided tape
* Picture hooks and wire
* Small nail
* Hammer

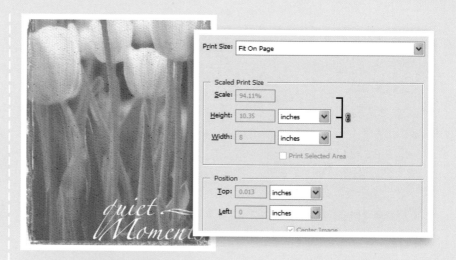

1 Open up your chosen image, or use the image featured here from Cottagearts.net, called Tulips Edge Pink.jpg. Print the image as large as possible, choosing **File>Print**. Set the Print Size to Fit on Page. Configure your printer settings to those specified by the manufacturer. In the case of Waterslide decal, it is Plain Paper and Normal quality. Print one copy of the image.

2 To remove any rough edges and to create a smooth surface for painting, sand the wooden frame using fine wet/dry sandpaper. To remove the dust, wipe with a clean, lint-free cloth.

3 To prepare the frame, use a wide paintbrush to apply a coat of artists' gesso. This seals the wood and gives the surface texture. Let the gesso dry.

4 To create a mottled pattern on the frame, use a sponge to apply an uneven layer of green paint to the frame. Dab the surface with the sponge, applying the colour for an uneven look. Let the paint dry.

5 Apply splotches of pink paint over the green paint with another sponge. As before, dab the paint over the green layer to achieve an uneven look. Don't try to cover the green; just accent it. Let the paint dry.

6 Apply splotches of cream paint over the pink and green using a clean sponge. Repeat the dabbing method. Again, don't try to cover the other colours; just accent them. Let the paint dry.

Tips

✳ WRAPAROUND TEXT

To create text that will wrap around the mirror, measure the approximate length for each of the four pieces of text, then type the text into a new image using multiple lines of type. Leave room between successive lines of type for cutting. Print the image onto the transfer paper, cut out the lines of type, and adhere to the mirror following the instructions.

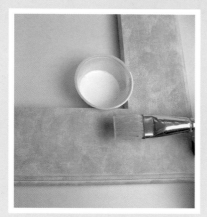

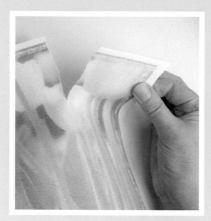

7 To create a smooth surface, sand the frame lightly with wet/dry sandpaper. Mix a 50/50 wash of white paint and water. Use a brush to apply a thin coat over the entire frame. This will veil the bright pink, green, and cream colours, creating a subtle effect in keeping with the image.

8 Tear the printed decal paper into two pieces, one for the top left-hand corner and one for the bottom right-hand corner of the frame. Tear the piece for the bottom right-hand corner in an L shape so that the text will appear across the bottom of the frame.

9 Check the placement of the decal pieces on the frame. If the pieces don't lie neatly on the surface, tear bits away from the edges to ensure that the decal lies flat.

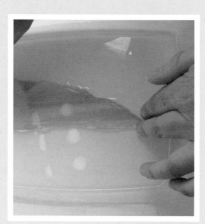

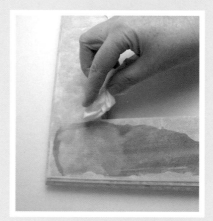

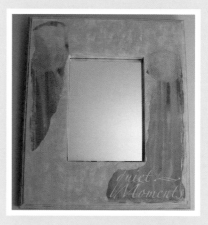

10 Fill the container with water. Submerge one cut-out decal in the water. Let it soak for 15 seconds or the length of time recommended by the manufacturer. Then remove the decal using your fingers.

11 Carefully slide the image off the backing sheet. Discard the backing. Position and press the image onto the frame. Smooth away any air bubbles using a wet finger. Use a damp sponge to soak up any excess moisture.

12 Add the second decal, repeating steps 10 and 11. Check that both are bubble-free and properly adhered. Set the frame aside to dry.

13 Place a soft cloth on the surface to protect the decals. Flip the frame over. Apply double-sided tape in strips to the frame inset where the edges of the mirror will rest.

14 Peel the backing from the double-sided tape and set the mirror in position. Gently press along all the edges to ensure that it is secure.

15 Use a hammer and nail to make two small pilot holes at opposite sides in the back of the frame. Screw hooks into the holes. Cut a length of wire. Thread one end through each hook and twist the wire to secure.

Tips

✳ FEATURE YOUR OWN PHOTOGRAPHS

To use your own photograph of flowers for this mirror, you will probably want to lighten it to coordinate with the whitewash surface. To lighten a photo, add a filled layer of white above the photo layer by choosing **Layer>New Fill Layer>Solid Color** and click OK. Select White as the colour. Display the Layer palette and decrease the opacity of the fill layer until the image is lighter, but still visible. Once printed, it is ready to use to decorate your mirror.

Mirror, mirror on the wall...

If you can bear to part with your newly decorated mirror, give it to a good friend or member of your family. It makes a superb gift.

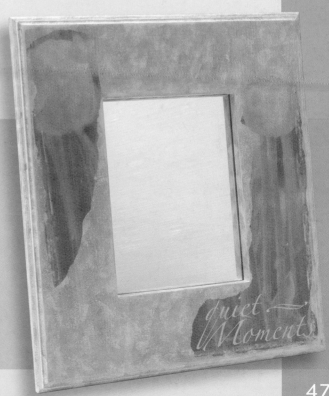

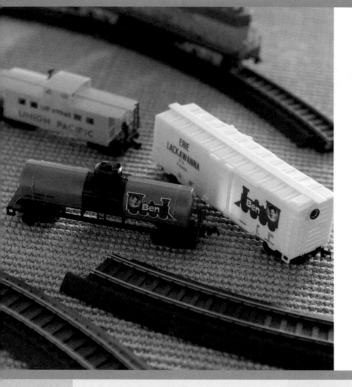

Model Train

While decals are often sold as items for decorating transparent surfaces, such as windows, they can also be used to decorate opaque surfaces. Here, ink-jet-printable decals were applied to the sides of individual cars of a child's toy train set. For interest, a configuration of shapes was inset with a photo and text, and then printed onto the decals. When the ink dried and the backing was removed, they were sticky enough to be adhered to the cars. The final result looks very professional and fun.

Materials

* Photo of child in digital format
* Sheet of decal paper for ink-jet printers
* Child's model train
* Water-based varnish (optional)

Tools

* Scissors
* Container for water
* Soft, lint-free cloth
* Paintbrush (optional)

1 Open an image of a child whose portrait you want to use on the model train. Create a new image by choosing **File>New>Blank File** and configure it to 2000 x 1500 pixels in size and select White as Background colour.

2 Select Blue as your Foreground colour to use for the train shape. Fill the new image with this colour using the Paintbucket tool.

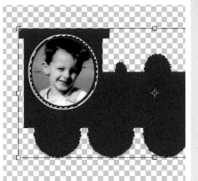

3 Click on the image of the child and use the Elliptical Marquee tool to make an oval-shaped selection around the child. Choose **Edit>Copy** to copy the selection. Click on the new document and choose **Edit>Paste** to paste in the image. Move the face just left and above the centre of the image.

4 With the child's face still selected, choose **Select>Modify>Expand**, and set the value to 15 pixels. Click OK. Your shape should be a little larger than the child. Set the Foreground colour to White and choose **Edit>Stroke (Outline) Selection**. Set the pixel value to 6, select White as the Color, and the Location to Outside. Click OK.

5 Display the Layers palette (**Window>Layers**) and select the Background layer. Click the Cookie Cutter tool, then, from the Shapes flyout menu, choose Objects and locate the Locomotive shape. Disable the Crop checkbox on the Toolbar. Click and drag a Locomotive shape over the child's face. Position and size the shape to suit the image. Press Enter to accept the shape.

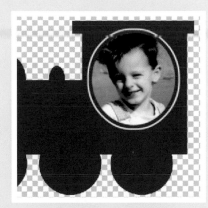

6 First flatten the image, then choose **File>Duplicate** and click OK. Reverse the image to make a second version by choosing **Image>Rotate> Flip Horizontal**.

7 Select the Type tool and choose a dark blue for the Foreground colour. Type the child's name on one train. Repeat this using another Foreground colour – this time in White. Size the two text items to the same size and place the dark blue one just to the right and beneath the white one to create a shadow effect. Repeat for the second train. Crop closely around each image using the Crop tool.

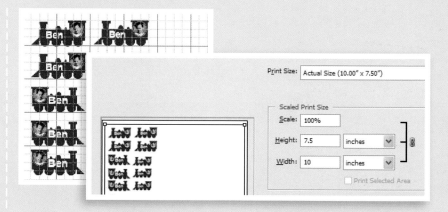

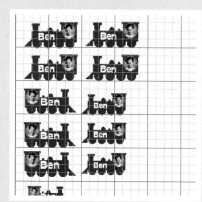

8 Measure the space available on the train to place your decals. In this case, create two small ones of 2.54 x 3.8cm (1 x 1½in) in size, and two further decals not higher than 1.9cm (¾in). To ensure that you print everything the right size, create a new document by selecting **File>New>Blank File** and size it to 25.4 x 17.78cm (10 x 7in) at 300ppi. Display the grid on this image by choosing **View>Grid**.

9 Select the first train image and choose **Select>All**. Choose **Edit>Copy Merged**. Click on the new blank image and choose **Edit>Paste**. The train image, face image, and text are all pasted as a single layer. Click on the layer and size the pasted image using the grid as a guide. Repeat until you have all the images you need at the desired size.

10 Choose **File>Print** and, from the Print Size list, choose Actual Size. Choose Page Setup, configure the paper orientation to Landscape, and click OK. Click Print and then Properties, and configure the Paper Type and Print Quality to those recommended by the paper manufacturer. Print the images onto the sheet of decal paper. Let them dry for at least half an hour.

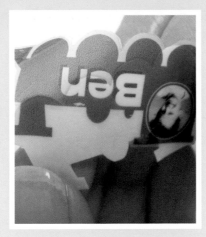

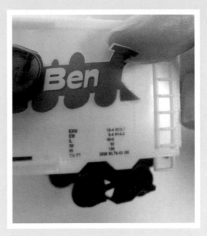

11 Use scissors to cut carefully around the perimeter of the images on the decal paper leaving a scant 1.5mm (1/16 in) border.

12 Fill the container with water. Immerse the images one at a time in the water until the image slides off the backing paper. Discard the backing paper.

13 Position each decal on the model and move it into position. To absorb the moisture, dab with a cloth. Repeat steps 12 and 13 with all the decals.

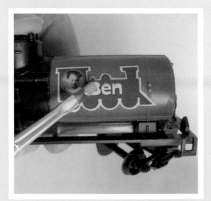

14 Once dry, paint the decals with a water-based varnish for added resilience, particularly if the finished item gets a lot of use.

On the right track

The decals work really well with the child's model train, but they can be applied to other toys, such as model cars and boats.

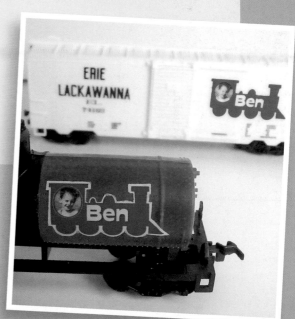

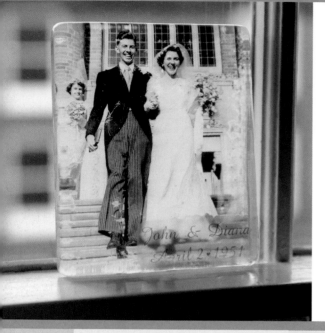

Wedding Plaque

This is a truly unique and creative project, and so simple to make. If you have a friend or relative's wedding or anniversary coming up, find a photograph of the couple and use it to illustrate a glass plaque. The decorated plaque makes an ideal paperweight, or it can be displayed on a mantelpiece or at a window. Clear Waterslide decal paper was used for this project because it adheres easily to glass.

Materials

* Clear glass plaque
* Wedding photo in digital format
* 2 sheets of Waterslide decal paper for ink-jet printers
* Clear varnish

Tools

* Tape measure or ruler
* Pair of scissors
* Container for water
* Paintbrush
* Shallow, plastic container
* Paper towel or small sponge

1 Measure your plaque to gauge the size of the required photograph. This glass plaque is 11.5 x 14cm (4½ x 5½ in).

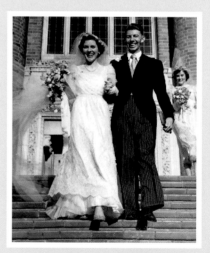

2 Open the image in your software and choose **Image>Rotate>Flip Horizontal**. The image will be adhered to the back of the glass plaque, so it needs to be reversed.

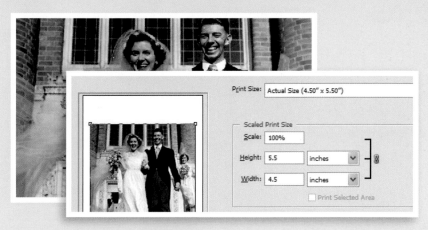

3 Crop the image to the print size using the Crop tool. Type the dimensions required and move the Crop Marquee into position to achieve a pleasing composition.

4 Print the image onto a sheet of the paper. Choose **File>Print** and check that the print size is correct. Choose the Page Setup option to configure the printer and set the Paper Size, particularly if you are using a small precut sheet of 21.5 x 13.9cm (8½ x 5½ in) paper. Set the Paper Type and Quality to that recommended by the manufacturer. Print the decal.

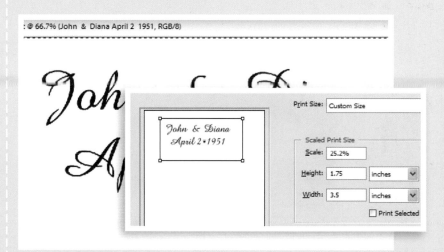

5 Create a new image (1000 x 500ppi should be large enough). Into this, type the text for the front of the glass. This doesn't have to be reversed because it will be affixed to the front of the glass.

6 Print the text onto a second sheet of decal paper, sizing it as desired. A good approach is to print the text to about two-thirds the width of the plaque.

Tips

✳ SET THE INK SAFELY

If your paper requires special spray to set the ink, always follow the manufacturer's safety instructions carefully. When spraying, always use a mask and goggles. Always spray in a well-ventilated area.

✳ CONVERTING TO MONOCHROME

To convert a colour image to monochrome to use for this project, choose **Image>Mode>Grayscale** and click OK to discard the colour information.

7 Use scissors to cut around the image on the decal paper. The image must be the same size or smaller than the back of your glass plaque.

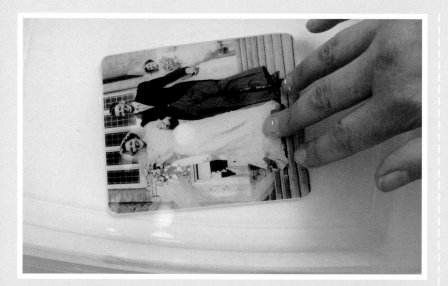

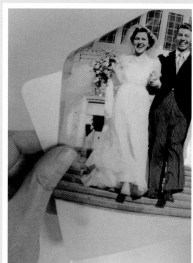

8 Follow the manufacturer's instructions for wetting the decal. Soak the decal in water for 10–15 seconds, removing the decal as soon as it starts to curl.

9 Slide the decal off the backing sheet and apply to the glass plaque.

54

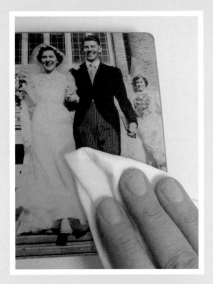

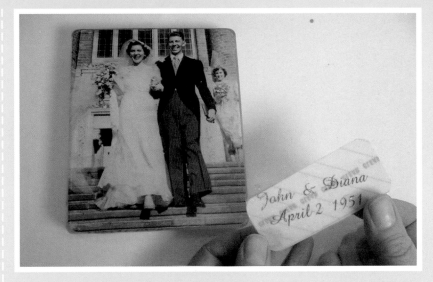

10 Use a wet paper towel or damp sponge to carefully blot the decal.

11 Repeat steps 7–9 to apply the text decal to the front of the glass plaque.

12 For added transparency and protection, use a brush to apply a light coat of varnish to the text decal on the front of the plaque.

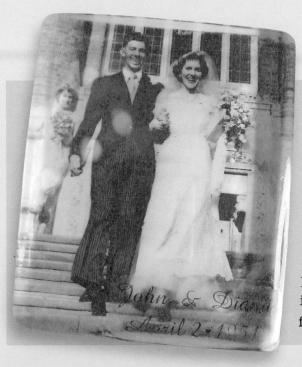

In the picture

This project is an attractive and clever alternative to presenting a favourite photograph in a picture frame.

Fabric Projects

✷ Appliqué Pillow **58**

✷ Christmas Banner **62**

✷ Angel Pillow **66**

✷ Doll's Dress **70**

✷ Kitchen Apron **74**

✷ Lavender Bag **78**

✷ Memory Quilt **82**

✷ Canvas Bag **86**

✷ Shoe Bag **90**

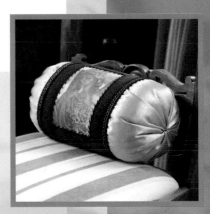

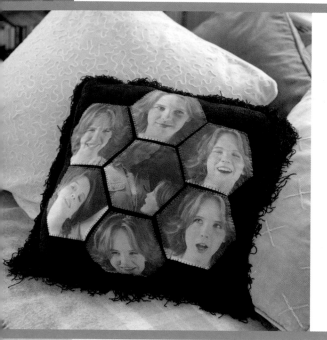

Appliqué pillow

For this project, you will need lots of photographs of a friend or family member. To create a consistent, dark background for our friend Jen, we draped a scarf behind her and took lots of photos as she talked, laughed, and had fun in front of the camera. Using a single backdrop and the same clothes throughout lends coherence to the project. We printed the photos onto pieces of cotton fabric and sewed portraits in a honeycomb configuration to make this wonderful appliqué pillow.

* Several photos of the same person in digital format
* Ready-made pillow, 48cm (19in) square
* 7 sheets of white printable fabric
* Spray quilting adhesive
* Contrasting-coloured cotton sewing thread

Tools

* Scissors
* Ruler
* Iron
* Handsewing needle
* Straight pins

1 Open your photos in Photoshop Elements. Arrange them on the screen and select seven that you like best. These will form your pattern. Choose your favourite photo and make it the central image. Compose the other six images around it.

2 Select the Cookie Cutter tool from the Toolbar and click on the Shape drop-down palette. Locate the small arrow in the top right of the Shape palette and click it. Choose Custom Shapes and, when it appears, click on the six-sided Hexagon.

3 In Shape Options, choose **Defined Proportions>From Center**. On the Toolbar, click the Crop checkbox. Click in the middle of the first image and drag to create a hexagon shape.

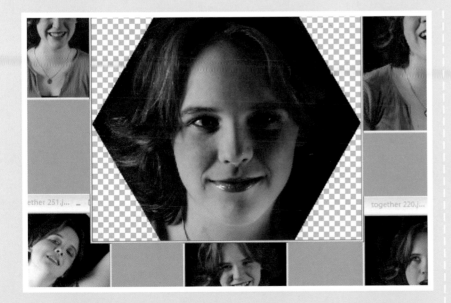

4 Drag the shape into position with your mouse. Click the Maintain Aspect Ratio icon between the Width and Height settings to ensure that you don't alter the ratio of width to height. Press Enter or double-click to crop the image to the shape.

5 Repeat step 4 to crop the remaining six images to a hexagon shape.

59

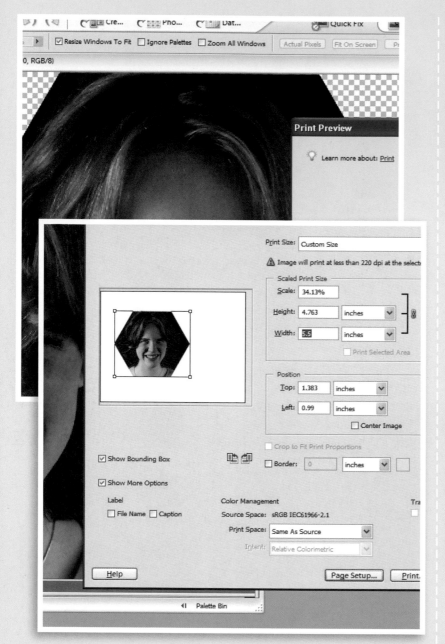

Repeat step 6 to print the remaining six images. Allow the fabric to dry overnight before continuing. Follow the manufacturer's instructions for setting the ink if there are any special requirements. When dry, pull the backing sheet away from each piece of printed fabric.

For the pillow size specified, print each photo so that it is approximately 14cm (5½in) wide. Choose **File>Print** and select Custom Size from the Print Size pull-down menu. Set the width to 14cm (5½in) and Elements will calculate the appropriate height. Select your printer and the paper quality. Use Plain Paper and Normal quality unless the paper manufacturer recommends something else, in which case, follow those instructions. Print the first image.

Cut around each image, leaving a 5mm (¼in) seam allowance. For the hem, turn the edge under by 5mm (¼in). Lay the image wrong side up and use the iron to press the crease. Repeat for the remaining pieces.

9 For the next part, work in a well-ventilated room. On a protected surface, spray the wrong side of the hexagon that will be featured in the centre of the design with a light coat of spray quilting adhesive. Then position the piece and press it firmly into place with your fingers so that it adheres.

10 Using a thick thread in a contrasting colour, sew this hexagon onto the cushion using a blanket stitch. The blanket stitch makes an attractive edge feature for the appliquéd shapes.

11 Spray adhesive on the wrong side of the next hexagon and adhere it to the cushion so that the sides of the two hexagons butt up, leaving approximately 7mm (⅜ in) between the two shapes. Sew this to the cushion using blanket stitch.

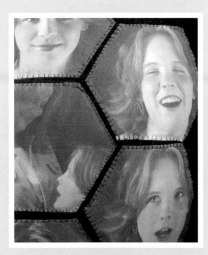

12 Continue in the same way, sewing the remaining five hexagons neatly into position until the project is complete.

Et voilà!

We've used a single subject for this pillow, but why not vary the theme and feature every member of your family?

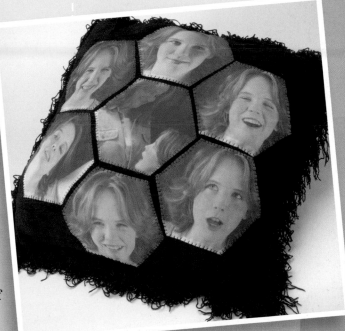

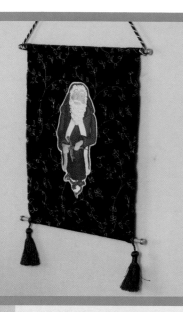

Christmas Banner

This festive Christmas banner comes into its own with the cheery addition of Santa Claus! The banner makes use of peel-and-stick fabric – a handy material to add the texture and flexibility of fabric without having to sew the image onto the project. The material is very easy to use – simply print on it and let it dry. Then cut the image to size, and peel the backing paper off to adhere the paper to the project.

* Seasonal ornament, decoration, or card to photograph
* Sheet of peel-and-stick fabric for ink-jet printers
* Fabric, 45cm (18in) in length and 60cm (24in) wide
* Coordinating-coloured sewing thread
* Gold acrylic paint
* Wood dowel, 76cm (2½ft) in length, 8mm (⁵⁄₁₆in) diameter
* Decorative cord
* 2 matching tassels
* 4 vintage gold bead caps, finials, buttons, or beads to finish ends of dowel

* Scissors
* Tape measure or ruler
* Iron
* Straight pins
* Sewing machine or handsewing needle
* Paintbrush
* C-clamp
* Coping saw
* Sandpaper and soft cloth
* Glue and clothespin

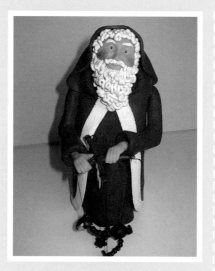

1 Photograph or scan a favourite Christmas ornament or decoration against a neutral background to ensure that you have enough contrast to enable you to cut out the image easily. Alternatively, scan a favourite holiday image, perhaps from a Christmas card.

2 Open the scanned or downloaded image and select around the object. Using the Magnetic Lasso tool, make a rectangular shape or select closely around the image so that it can be cut away from its background.

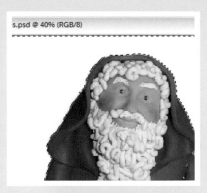

3 If you are making a cutout, feather the selection by choosing **Select>Feather** and set the Feather value to 2 pixels. This softens the edge of the cutout.

4 Invert the selection by choosing **Select>Inverse**. Select White as the background colour and press Delete to remove the background. This will leave you with a cutout on a white background.

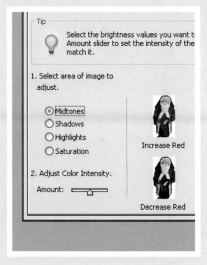

5 Use **Select>Deselect**, then use the Crop tool to select close around the image and press Enter to crop the image to size. This ensures that the image will print at maximum size on your paper.

6 If desired, change the colour of parts of the image to suit your project. We wanted a darker red coat on our Santa for a festive flavour. Use the Magic Wand tool to select the area for recolouring. Using **Select>Feather**, feather the selection by 2 pixels to soften the edge.

7 Choose **Enhance>Adjust Color>Color Variations** and select the various options until you adjust the colour in the selection. Increase the darkness and the blue, and decrease the red until you are pleased with the colour. Then select OK and rename and save the image.

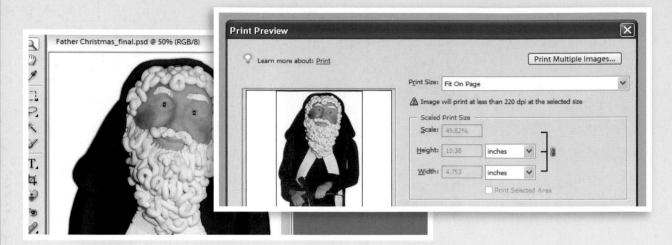

8 Choose **File>Print** and set the Print Size to Fit to Paper. Print the image onto printable fabric, making sure that you set the paper setting and the quality recommended by the manufacturer. When printed, allow the fabric to dry completely.

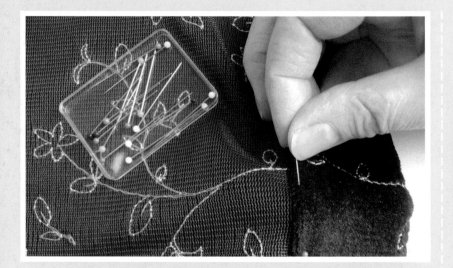

9 To make the banner, use scissors to cut a piece of fabric measuring 35.5cm wide x 48cm long (14 x 19in). To make a hem, place the piece right side down and turn under 1.25cm (½in) along the long sides, then 1.25cm (½in) again. Use a hot iron to press. Pin, then sew along the edge on both sides to secure. To make pockets for the dowels, lay the fabric on its wrong side and turn it under 1.25cm (½in) on each short side, and then turn under again 1.25cm (½in). Use the iron again to press, then sew along the edge, leaving the ends open.

10 Use scissors to cut around the printed image of Santa Claus, leaving a 5mm (¼in) margin all around. To make a decorative border, use a paintbrush lightly loaded with gold paint to paint a narrow strip of gold around the edges. Let the paint dry completely.

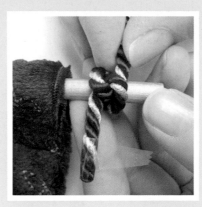

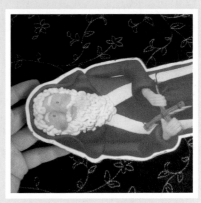

11 Use a C-clamp to secure the dowel to your protected work surface. Use a saw to cut the wood dowel into two lengths, each 37cm (14½in) long. Sand the ends lightly, then wipe them with a damp, soft cloth. Use a brush to paint each piece with gold acrylic paint. Let the paint dry completely.

12 When dry, insert one rod into a pocket at each shortside. Measure and cut a 60cm (24in) length of cord. Attach the ends to opposite ends of the rod at the top of the banner, securing each end with a knot. Tie the tassels to opposite ends of the rod at the bottom of the banner.

13 Peel away the backing paper from the Santa Claus image. Carefully position and press the image in place on the banner. To adhere, smooth the image using the palm of your hand.

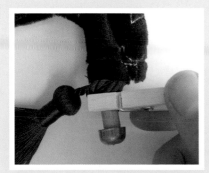

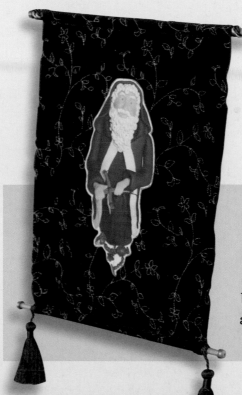

14 Glue the cords of the tassels in place onto each end of the rods. Use a peg to hold them in place while the glue dries. If desired, add a finial, button, or gold bead to each end of the rods to finish them off neatly. We used vintage gold bead caps.

Santa Claus is coming to town!

This makes a great holiday centrepiece, but it can also be adapted to any special occasion.

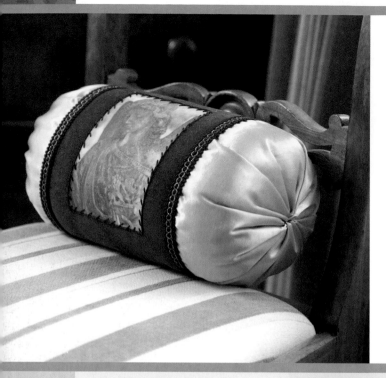

Angel Pillow

Silk is the most luscious printable fabric available. Its lustrous sheen and soft texture create an appealing context for your favourite photos and open a world of creative opportunity. Here, an illustration printed on silk is framed by faux suede and satin, the pieces stitched together to create a decorative pillow.

* Angel photo or other image in digital format
* Sheet of silk for ink-jet printers
* 45cm (½yd) gold satin or shantung fabric
* 30cm (⅓yd) maroon faux suede fabric
* Coordinating-coloured sewing thread
* 1.3m (1½yd) black decorative rickrack
* Spray quilting adhesive
* Black six-strand embroidery floss
* Basting thread
* Roll pillow with a small neck, 33cm (13in) long, 53cm (21in) in circumference

Tools

* Scissors
* Straight pins
* Sewing machine
* Embroidery needle
* Handsewing needle

1 Open the image you'd like to feature on your pillow. Size the image to 10 x 15cm (4 x 6in).

angel.tif @ 33.3% (RGB/8)

New Size: 12.4M
Width: 1 inches
Height: 1 inches
☑ Relative
Anchor:
Canvas extension color: Background

① Select Printer:
hp deskjet 9300 series

② Select Type of Print:
Individual Prints

③ Select Print Size and Options:
5" x 7"
☐ One Photo Per Page
Use each photo 2 time(s)
☐ Crop to Fit

2 To make a seam allowance around the image, choose **Image>Resize>Canvas Size** and click the Relative checkbox. Set the Width and Height to 2.5cm (1in) to add a small sewing allowance around all sides of the image. Click in the middle of the nine squares in the Anchor selector and click OK.

3 Choose **File>Print Multiple Images**. Set Print Size to 12.7 x 17.7cm (5 x 7in) and set the Use Each Photo value to 2 so that two copies of the image are printed. Select Page Setup and then select the Paper Size, Printer, and Quality. Print the image.

4 Let the printed image dry at least a few hours, according to the manufacturer's instructions. Carefully peel away the backing paper from the silk fabric, then cut out the images from the fabric.

5 Measure and cut the fabric into strips. For the pillow size specified, cut two 20 x 56cm (8 x 22in) strips of gold satin or shantung and one 19 x 56cm (7½ x 22in) strip of faux suede.

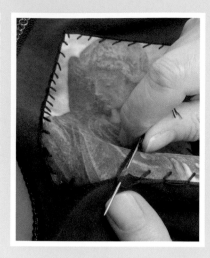

6 Pin and machine stitch one strip of gold satin to opposite sides of the faux suede along the long sides. On the right side, pin and sew black rickrack over the seams between the gold and red fabric.

7 Spray quilting adhesive on the back of the cut-out images and place the images in position.

8 Use a threaded embroidery needle with a length of six-strand embroidery floss to sew the images to the suede section of the pillow front, using blanket stitch.

9 Turn over the long sides of the gold fabric by 1.25cm (½in) and sew a hem. Fold the fabric in half with right sides together, matching colours on the raw edge. Pin a seam starting at one end of the pillow, 1.25cm (½in) in from the raw edge and around 12.5cm (5in) long. Repeat at the opposite end of the fabric. Sew these seams, leaving the suede fabric unsewn. This will provide a pocket for inserting the pillow.

Tips

✱ USING PILLOWS OF DIFFERENT SIZES

When covering a pillow that is larger or smaller than the one used here, measure the pillow from the centre point of one side across to the opposite centre point and add a seam allowance of 9cm (3½in). Divide this value into three equal pieces to determine the width of each piece of fabric. The length of each piece will be equal to the circumference of the pillow, plus an allowance of 2.5cm (1in) for seams.

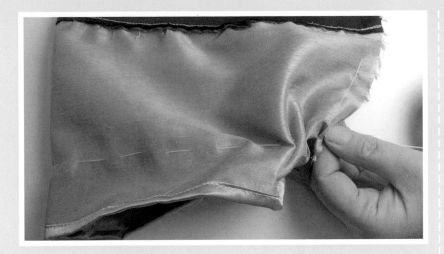

10 Use a handsewing needle and thread to sew large basting stitches around the gold fabric, 3.8cm (1½in) in from the top edge. Repeat at the opposite end of the cushion.

11 Tightly pull the basting threads to gather the fabric. Knot tightly using a backstitch. Turn the project right side out to finish.

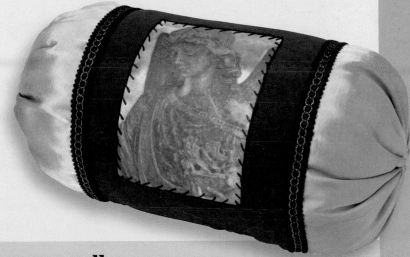

12 To finish, insert the pillow into the cover. Use a threaded handsewing needle and whipstitch the opening closed.

You're on a roll

With your first pillow finished, you might like to create a series of matching pillows in coordinating colours to accent a couch or a bed.

Doll's Dress

If you've ever dreamed of designing your own fabrics, you'll find printable fabric inspiring to use in your sewing projects. Any image can be applied to fabric, adding personality and style to your tailor-made creations. For this project, a charming print of flowers and a child's portrait was arranged in a simple vignette and used to decorate the bodice of a doll's dress. The technique can be used to create uniquely decorated apparel for a child's collection of stuffed animals.

Materials

* Photo of flower motif in digital form or use the featured image from the download site

* Photo of child

* 7 sheets of printable white cotton fabric for ink-jet printers, 21.59 x 27.94cm (8½ x 11in)

* Plain, white paper

* Coordinating-coloured cotton sewing thread

Tools

* Scissors

* Straight pins

* Sewing machine

* Handsewing needle

1 Open your own images from the software or use pinkflower.tif from the download site (http-design.com). Create a new image onto which you can assemble the flowers by choosing **File>New>Blank File**. Set the width to 27.94cm (11in) and the height to 21.59cm (8½in). Set the Color Mode to RGB Color and the resolution to 200ppi. Click OK.

2 Click on the flower image and, with the Layers palette showing, drag and drop the flower background layer onto your new empty image. Size the image to around ⅛th of the size of the image itself. Use the Move tool to place it in the top left-hand corner of your image.

3 Use the Eyedropper tool to sample colours from the flower image for use as a background of the paper. We chose a medium pink. Select the Paintbucket tool and, from the Layers palette, choose the desired background layer for the new image. Click the image to fill with your chosen colour.

4 Click the Eraser tool and select a soft brush with a size of approximately 45 and a high opacity value. Click the layer with the flowers on it in the Layers palette and use the Eraser to remove some of the defined edges of the flower layer.

5 In the Layers palette, right-click on the layer containing the flowers and choose Duplicate Layer. Use the Move tool to move the flowers on this new layer to another position on the image. Repeat the process as many times as necessary to fill the background, but without actually covering all of it. Try to space the motifs as evenly as possible for a more professional look.

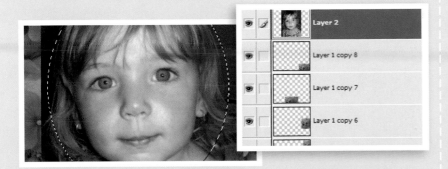

6 Create a second copy of this image by choosing **File>Duplicate** and click OK. Click on the child's photo and, with the Layers palette showing, drag and drop the background layer onto the second copy of your flower image. If necessary, move this layer to the top layer. Use the Elliptical Marquee tool to make a selection around the child. Choose **Select>Feather** and set a 20-pixel feather, then choose **Select>Inverse** and press Delete to remove the unwanted background.

7 Choose **Select>Deselect**, then use the Move tool to move the portrait of the child to the centre of the image. Size it in proportion to the bodice on the doll's dress, in our case the image size is 21.59cm (8½in) tall, or to the size of your design field.

8 To print the images, select one and choose **File>Print**. From the Print Size list, choose Fit on Page. Click Page Setup and choose Landscape paper. Click Printer, then Properties to set the Paper Type and Print Quality – in this case, use Plain Paper and Best Quality. Click Print. Print one sheet of printable fabric with the child's face on it, and six sheets with the plain flower image.

9 Peel the backing paper from each of the sheets of printed fabric. The fabric will be non-sticky for easy cutting and sewing.

10 Print the pattern pieces onto sheets of paper and cut out. Lay the pattern pieces over the fabric pieces, making sure that the child's face is centred on the dress top. Cut out each of the pattern pieces as instructed on the pieces.

11 With right sides together, raw edges even, stitch the shoulder seams of the dress, and gather the top of the sleeves using a basting stitch. With right sides together, stitch the front and back facings together.

12 With right sides together, stitch the facing to the collar of the dress, as shown.

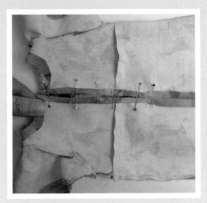

13 Sew the sleeves to the dress. Hem the edges of the sleeves. To sew the front and the back of the bodice together, sew the sleeves to the raw edge.

14 With right sides facing, raw edges even, machine stitch the front and back of the skirt pieces together along the side seams. Gather the front of the skirt using a basting stitch. Then pin and sew the skirt to the top, matching the side seams and easing the gathering as required to fit the doll.

15 Sew the back of the skirt partway from the hem to the waist and then hem the remainder to provide an opening to slip the dress on the doll.

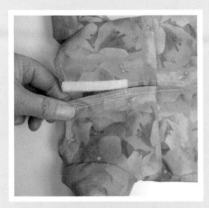

16 Sew the back opening seams flat Position and sew the Velcro strips to the top back of the dress to secure.

Flower child

This delightful project will give your child a special sense of pride when out and about with her doll.

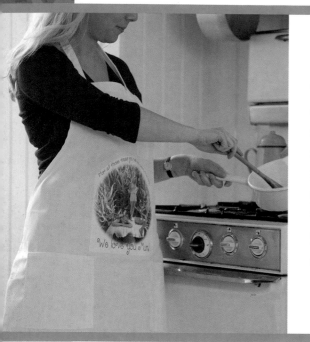

Kitchen Apron

This project provides a good chance to take fantasy photos of the kids in the style of movies that shrink children to tiny sizes. For this image, you will also need a close-up of a scene in which they can all be featured. Here, a mushroom provides an appealing platform for the three girls photographed and placed in the composite image. The image was composed and then printed on special ink-jet-printable fabric. The fabric can be adhered to a project using a hot iron, making it easy to complete and resistant to wear and tear.

Materials

* Photos of children and recreational scenes in digital format
* Sheet of adhesive fabric for ink-jet printers
* Kitchen apron

Tools

* Scissors
* Iron
* Ironing board or towel

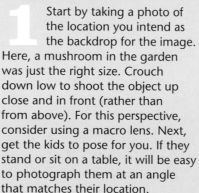

1 Start by taking a photo of the location you intend as the backdrop for the image. Here, a mushroom in the garden was just the right size. Crouch down low to shoot the object up close and in front (rather than from above). For this perspective, consider using a macro lens. Next, get the kids to pose for you. If they stand or sit on a table, it will be easy to photograph them at an angle that matches their location.

2 Open the photos you plan to use. Use your choice of selection tools to make a selection around the first figure. Use the Magnetic Lasso tool and then the Lasso tool to tidy up the selection. Choose **Select>Feather** and set a feather value of 2 pixels.

3 Choose **Edit>Copy** to copy the selected figure. Switch to the background image and choose **Edit>Paste**. The figure will appear on a new layer. Click the Move tool and drag on the sizing handles to size the child. Click the Maintain Aspect Ratio icon between the Width and Height values in the Move tool options, to ensure that the figure is sized proportionately.

4 Repeat steps 2 and 3 for each member of the group. As each is pasted into the image, adjust their size and place him or her in the desired position.

5 To obtain the right perspective in your image, arrange and size the children so that those closer to the camera are larger than those farther away. Drag the layers up or down in the Layers palette to effect this. Name each layer by double-clicking on its name and type in a new name to help you identify what is on each layer.

6 To enhance the realism, add in natural-looking shadows where the children are placed. To do this, choose **Layer>New Layer** and press Enter. Choose a Foreground colour of Black or Grey and select the Brush tool. Drag the new layer below one of the child layers and use the paintbrush to create a shadow around the child. The shadows should all fall at the same angle. Adjust the Opacity as necessary. Use the existing shadows in the images as guides.

7 To enhance the shadows, create a new layer and paint on a shadow for each figure. To blend the shadows into the image, click the shadow layer in the Layers palette and adjust the Opacity slider to lighten the shadow effect. If necessary, delete part of the shadow by selecting the shadow layer and use the Eraser tool to erase it.

Tips

❋ SHRINK THE KIDS ANYTIME!

This project can be easily adapted as a seasonal project. Create an image by taking a photograph close up of, for example, gifts under the Christmas tree. Add images of the kids playing with the wrapping or looking at the gifts. Apply the image to an apron to wear during the festive season, or use it for Christmas cards or even refrigerator magnets.

8 When you're satisfied with the results, choose **Layer>Flatten Image**. This merges all the layers into one so that you can crop the image.

9 Set the Background colour to White and click the Elliptical Marquee tool. Drag an oval shape around the image. Choose **Select>Feather** and set a large feather value – around 20 or more pixels – to give the image a soft edge, then click OK. Choose **Select>Inverse** to invert the selection and then press Delete to remove the background.

10 Select the Type tool and select a Foreground colour, Font, and Font size. Click on the image and type your text. Here, there are two lines of text.

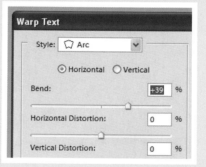

11 Use the Move tool to move the lines of text into position and size them as desired. To wrap the text in an arc, click the Type tool and click on the text. Click the Create Warped Text button (or choose **Layer>Type>Warp Text**). Choose Arc as the Style, click Horizontal, then click OK.

12 Use the Move tool to drag and resize the arc text so that it forms shapes in the desired curve. Use the Crop tool to crop close around the image so that it can be printed at the largest possible size.

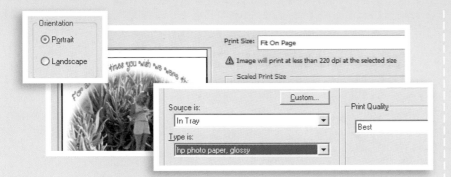

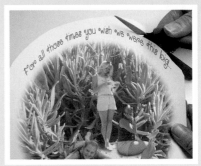

13 To print the image, choose **File>Print**, and from the Print Size list, choose Fit On Page. Choose Page Setup and choose your Paper Orientation. Click the Printer button and select Printer, then click Properties to select the Paper Type and the Print Quality. These should match the manufacturer's recommendations. In this case, select Plain Paper and Best Quality. Print a copy of your image onto the printable side of the fabric and let dry for at least 15 minutes.

14 To create the circle shape, use scissors to cut closely around the image to remove the excess fabric paper.

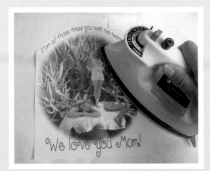

15 Adhere the image to the apron. First, pour out all water in the iron. Preheat the iron to the required temperature and turn off the steam setting. Iron the apron to remove any excess moisture. Place the apron right side up on an ironing board or towel, then place the fabric shiny side down (printed side up). Iron the fabric image to the apron for a few seconds to melt the adhesive.

It's a cover up!

This apron is sure to be loved and well-used around the home.

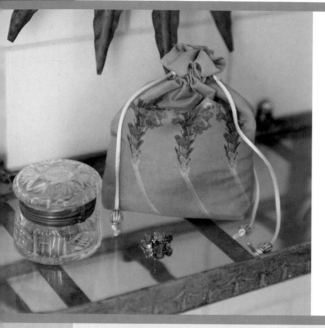

Lavender Bag

Printable silk is the most wonderful fabric to use for making many craft projects. Here, the softness and lustre of the fabric is used to maximum effect in creating a lavender bag that can sit atop your dresser or nestle in a drawer, adding sweet scent to the room or to your clothes. Printable silk works in the same way as most printable fabrics. The backing paper provides structure so that the paper moves easily through the printer. Then the paper is peeled away, leaving behind soft fabric that can be sewn into little bags or slipcases.

Materials

* Image of lavender plant from the download site, or use your own image in digital format
* 2 sheets of silk fabric for ink-jet printers
* Coordinating-coloured sewing thread
* 100cm (40in) white cord
* 4 silver beads with large holes
* Loose, dried lavender buds

Tools

* Straight pins
* Tape measure or ruler
* Sewing machine or handsewing needle
* Small scissors
* Small safety pin

1 Create a new document by choosing **File>New>Blank File**, set up a document 21.9 x 27.9cm (8½ x 11in) size, and set to a resolution of 150ppi using the dialog options. Click OK.

2 Select the Paintbucket tool and choose Lavender as your Foreground colour to fill the image.

3 From the download site (http-design.com), select image Lavender.psd. Use **Select>Load Selection>Lavender** and click OK to load the selection around the lavender flower. Choose **Edit>Copy**.

4 Switch to the image you created and choose **Edit>Paste**. Choose **Image>Transform>Free Transform** and reduce the size of the stems of the flowers to just under half the height of the image. Press Enter to confirm the transformation.

5 Select a white Foreground colour and click the Type tool. Key in the following definition of Lavender, pressing Enter at the end of each line: LAVENDER (lav'en•der), *Lavendula officinalis*, n. a plant with clusters of typically blue purple flowers (although colours of pink and white are not known), that produce a fragrant oil used in perfume.

6 Repeat steps 1 to 4 to create the image for the back of the lavender bag. Use the same lavender image and no text. Repeat the **Edit>Paste** process to paste the image in three times. Arrange the blooms in parallel lines.

Tips

✱ USING SPECIAL CHARACTERS

To get the characters for the definition of Lavender in the Windows operating system, choose **Start>All Programs> Accessories>System Tools> Character Map**. Select Times New Roman as the font, and locate and select the characters to use that aren't on the keyboard. Click Copy, then switch to Photoshop Elements and, with the Text tool selected and the same Times Roman Font in use, press Ctrl+V to paste in the characters.

79

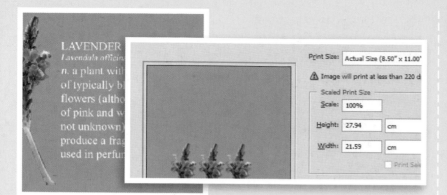

7 Choose **File>Print** and print each image onto a separate sheet of silk fabric at full size using the printer settings recommended by the paper manufacturer. Be sure to load the paper into the printer so that the printer prints onto the fabric side. Print. Then let the ink dry for an hour or as recommended.

8 Gently peel the backing paper away from the silk fabric so that you have two sheets of printed silk. Discard the backing paper.

9 Place right sides of the fabric together, ensuring that the grain of the fabric runs in the same direction. Pin the right sides of the fabric together, leaving the top raw edge open. Mark two points 7.6cm (3in) and 8.9cm (3½in) from the top raw edge of the bag on each side. These markers indicate the casing for the cord that will tie the bag together, and you mustn't sew between them. Machine stitch around the three pinned sides, leaving the casing for the cord unsewn.

10 Flatten the two bottom corners of the bag and machine stitch across the corner, 2.5cm (1in) in from the point of each corner. This gives the bag small 'feet' to help it 'sit' up a little better on a surface.

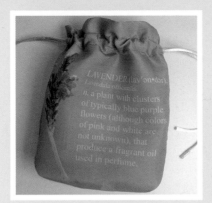

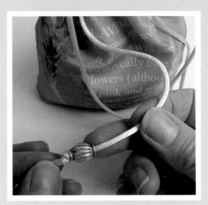

11 On the wrong side of the fabric, turn the top of the bag under 1.25cm (½in) and then turn the top under another 3.8cm (1½ in). Sew along the bottom of the hem you have created and then again 1.25cm (½in) above this mark to create a narrow casing for the cord.

12 Turn the bag right side out. Cut the cord into two 50cm (20in) lengths. Attach a small safety pin to one end and insert it into one hole, pushing the pin around the channel and back out of the entry hole, pulling the cord through the casing. Repeat with the second cord, this time starting and finishing in the hole at the opposite seam.

13 Thread a large silver bead on the end of the first cord. Knot the cord to secure it. Repeat to add one bead each to the ends of the remaining cords. Fill the bag with dried lavender and pull the cords tightly to close the bag.

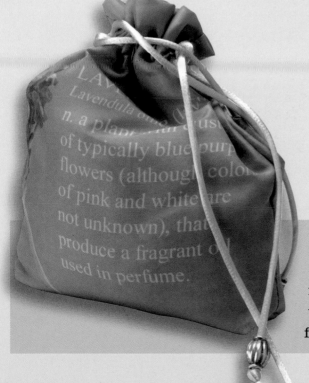

Sweet smell of success

Once you've made a bag for lavender, you may be inspired to make several more, filling them with dried rose buds and petals for a fragrant alternative.

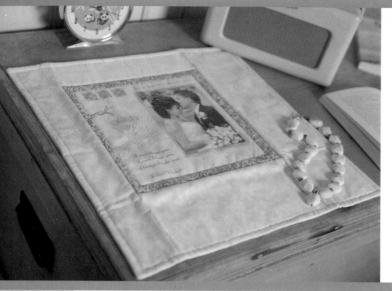

Memory Quilt

For the sewing enthusiast, this is a very special heirloom project, which uses freezer paper readily available from your local supermarket. Freezer paper provides a sturdy backing and can be ironed onto almost any fabric. It is useful for carrying fabric through your printer. Used this way, your ink-jet printer can print onto most fabrics. We've used muslin for this lovely memory quilt.

Materials

* Pure Bliss Memory Page Template from the download site, or use your own scrapbook template in digital format
* Muslin, 21.5 x 27.9cm (8½ x 11in)
* Freezer paper, 21.5 x 27.9cm (8½ x 11)
* Inner border fabric, 12cm (⅛yd)
* Outer border fabric, 30cm (⅓yd)
* Coordinating sewing thread
* 46 x 46cm (18 x 18in) thin quilt batting
* 46 x 46cm (18 x 18in) muslin or patterned quilt backing fabric

Tools

* Tape measure or ruler
* Sewing machine with walking foot attachment
* Scissors
* Rotary cutter
* Cutting mat
* 41 x 61cm (6 x 24in) rotary cutting ruler
* Straight pins
* Pencil
* Iron
* Sewing needle

1 Go to the download site (Cottagearts.net), select the Memory Page Template by choosing **File>Open,** and browse your system for the template you want to use. We chose Pure Bliss ScrapOver CottageArtsNet.png.

2 Choose **File>Open** and browse your system for appropriate photos to use. Select the file and click **File>Open**. Select the Move tool on the Toolbar. Click on the photo and drag it onto the template.

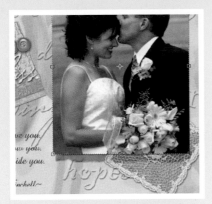

3 Using the Move tool, resize the photo, keeping it in proportion by holding the Shift key while dragging inwards or outwards to size the photo to match the opening in the template. Display the Layer palette, right-click on the Photo layer, and choose Rename. Type 'Photo' and press Enter – this helps you keep track of what is on this layer.

4 Click the Background layer in the Layer palette – this is the bottom-most layer. Click on it and drag it upwards until it is above the Photo layer. The photo is now perfectly sized and will have an automatic drop shadow around it.

5 Click the Text tool on the Toolbar, select a font (for example, Bickley Script), and set the Point Size to at least 28. Click the Text Color box and, using the Color Picker tool, click on any colour in the layout you'd like for your text colour. I chose the dark grey in the lower left quote.

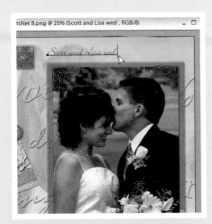

6 Make sure that you have the top layer in the Layers palette selected and click on the image where you want the title to appear. Type your text and adjust its position and size, if necessary.

7 Save your file as a Photoshop format (PSD) file to retain layers by selecting **File>Save** and choosing the format PSD from the Save As Type dialog. Choose **File>Print**. In the Print Preview Dialog, set the Print size to Actual size and check that the Width is set to 20cm (8in) and that the Center Image checkbox is checked. Select your printer and set the Paper Type to Other, then select either the Normal or Best Quality setting.

83

8 To prepare the muslin and freezer paper, use a tape measure or ruler to measure 21.9 x 27.9cm (8½ x 11in) rectangles of each, and scissors to cut out the muslin and freezer paper. Lay the muslin over the glossy side of the freezer paper, edges even. Iron the muslin to adhere on a medium heat.

9 Place the muslin/freezer paper combination in the printer so that it prints on the muslin side. Print.

10 Empty the iron of all water to prevent steam. Press the fabric, keeping the iron moving. The ink will remain water-soluble, so you will not be able to wash the quilt. Should you wish to make a washable quilt, use a waterproof ink-jet ink instead.

11 To make the narrow inner fabric border, use the rotary cutter, mat, and ruler to cut an accent strip 2.5cm (1in) wide, that measures the full length of the fabric. For the wide outer border, cut two 12.7cm (5in) strips in a coordinating-coloured fabric.

12 If desired, trim 5mm (¼in) around the printed memory page. Pin the narrow border to the raw edges of the memory page right sides together so that the seam aligns with the outer edge of the printed memory page. Sew a 5mm (¼in) seam allowance. Repeat for the wide outer border. Gently press the seams outwards. Trim as desired with a rotary cutter, mat, and ruler. We cut our borders asymmetrically to provide some variation in design. To do this, we measured out from the seam 6cm (2½in) and cut the top and left-hand borders. We left the bottom and right-hand borders as they are.

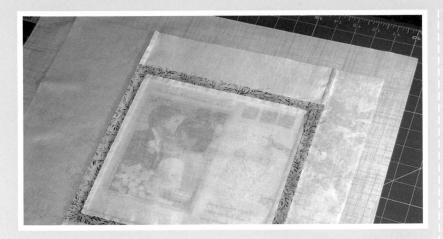

13 Trim the quilt batting to the size of the quilt. On a flat surface, lay the quilt backing right side up. On top of this, lay the quilt top right side down. Layer the batting on top, matching the edges to the quilt top. Pin around the edges, making sure that all the layers lie flat. Using a walking foot attachment on the machine to prevent puckering, machine stitch a 5mm (¼in) seam allowance around the perimeter of the quilt layers. Leave a 7–10cm (3–4in) opening at the bottom of the quilt for turning. Turn the quilt right side out, using the eraser end of a pencil to make crisp corners. Use an iron without steam to press the quilt. Press the opening under.

14 Using a walking foot attachment and stitch length of about 3, machine-quilt in the ditch of each border and quilt 7mm (⅜ in) from the edge of the quilt to give the look of a binding.

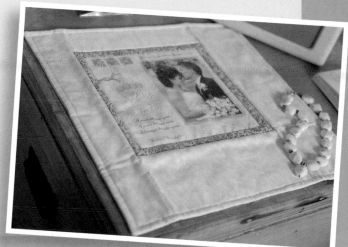

15 To finish, thread a handsewing needle with matching thread and slipstich the opening closed.

All stitched up!

This unique printing and quilting technique can be applied to a project of any size, from adorning a guest bedroom to a baby's cot.

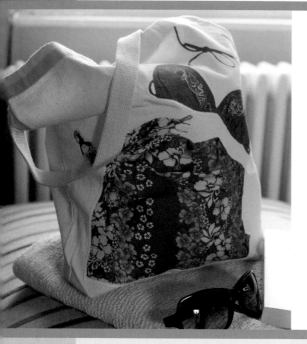

Canvas Bag

We've all planned shopping trips or days at the beach only to spend hours trying to find an appropriate item in which to carry all the necessary accoutrements for the expedition. Well, no longer. Now, you can make a roomy shoulder bag to suit any occasion. Here, an image of a two-piece bathing suit is printed on adhesive fabric and used to decorate a sturdy canvas bag. For a more finished look, sew a border around the image.

Materials

* Pair of bikinis or bikini and matching sarong to photograph
* 2 sheets of adhesive fabric for ink-jet printers
* Plain canvas bag, approximately 38 x 38cm (15 x 15in)
* White cotton sewing thread

Tools

* Scissors
* Iron
* Hand-sewing needle

1 To match the motif shown here, photograph a two-piece bathing suit or bikini and a matching sarong against a white or light-coloured background. Using a plain background makes the process of cutting out the image a much easier task.

2 Open the photos in your software. Make a selection around the object in the first image. If you photographed it against a plain background, click on the background with the Magic Wand tool to select it. Hold the Shift key down as you click on other areas of the background until it is all selected.

3 Add a feather to your selection by choosing **Select>Feather** and add a 3-pixel Radius feather. Set the Background colour to White and press the Delete key to remove the background, replacing it with white.

4 Repeat steps 2 and 3 for the second item of clothing you've photographed so that both are extracted onto a white background.

5 If your items are not the same colour, you can now colour-correct one to match the other. First, select the image and then choose **Enhance>Adjust Color>Replace Color**. Click the Eyedropper button and click on a colour in the image to select it. Adjust the Fuzziness slider until you have the right amount of colour selected. To add more areas of colour, click the Add To Sample Eyedropper and continue to click on areas in the image to select them. When the Preview image shows in white the exact area you want to recolour, disable the Eyedropper buttons.

6 Click the Result Color swatch in the bottom right of the dialog, then click with your mouse on the second image to select a colour to replace the selected colour. When you are satisfied with the colour results, click OK to confirm the change.

87

7 If desired, repeat the process to select and then replace other colours in the image – for example, you can make the bikini top red to match the sarong, as shown, and replace the purple with white. You'll hardly guess they are not matched together.

8 Select the first image to print and choose **File>Print**. From the Print Size dialog, select the appropriate size for the image. Choose 8 x 10 for the sarong motif so that it prints at approximately 20.32 x 25.4cm (8 x 10in). Click Page Setup and then Printer and Properties to configure the Paper Type and Print Quality for the paper. Use Plain Paper and Best Quality.

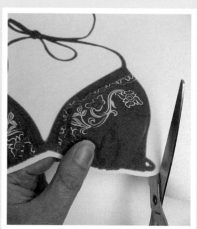

9 Repeat step 8 to print the second object, this time printing it at a size relative to the first motif. Size the bikini top to 17.78 x 18.54cm (7 x 7.3in) to make it smaller than the sarong.

10 Cut carefully around each image, leaving a margin of approximately 3mm (⅛in) all around.

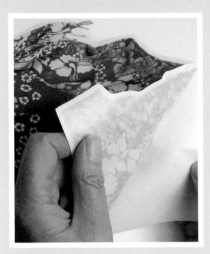

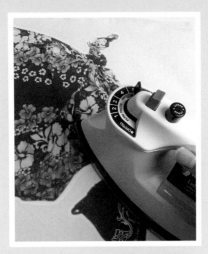

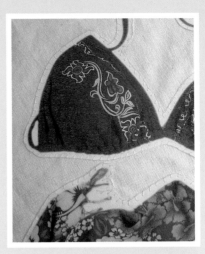

11 Peel away the backing paper from the images and place the first one in position on the canvas bag.

12 With a hot iron, but not steam, iron the fabric onto the canvas bag, following the manufacturer's instructions. Repeat with the second motif.

13 Using a handsewing needle and white thread, stitch around the images using a blanket stitch to secure them to the canvas bag, protecting them against wear and tear, and to give them a decorative finish.

It's in the bag!

The appeal of this project is its flexibility. Plain canvas bags are widely available, and adding an adhesive fabric motif is an economical and stylish way to customize one.

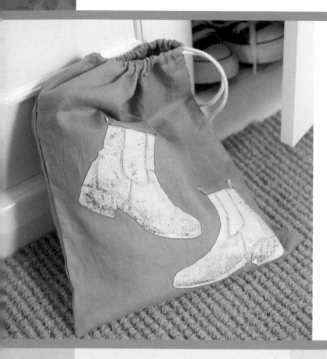

Shoe Bag

Adhesive fabric is a wonderfully versatile product. All you need is a sturdy iron and a bit of care and patience when adhering the unique material to your chosen surface. The appeal of printing on adhesive fabric is that you can apply any image to any piece of fabric and then stitch the printed fabric into great accessories. Here, we've printed an image of a favourite pair of jodhpur boots, and then made a bag with a pull string.

Materials

* Jodhpur boots or other favourite footwear to photograph
* 2 sheets of adhesive fabric for ink-jet printers
* ½yd (45cm) fabric (for example, medium-weight linen)
* Coordinating cotton sewing thread
* 1yd (1m) cord

Tools

* Tape measure or ruler
* Straight pins
* Sewing machine
* Iron
* Safety pin
* Scissors

1 Shoot a photo of a favourite object of footwear and download the image to Photoshop Elements. Use a selection tool to select around the image – we used the Magnetic Lasso tool.

2 Choose **Select>Feather** to feather the selection, set the value to 2, and click OK. Choose **Select>Inverse** to invert the selection. Now you have everything selected but the image itself. Set the background colour to White and press Delete to remove the background.

3 Choose **Select>Deselect**. Choose **Filter>Stylize> Glowing Edges**. Adjust the sliders until the edges in your image are well-defined. Select OK when you are satisfied with your adjustments.

4 Choose **Filter>Adjustments >Invert** to turn the image into a negative of itself.

5 To recolour the image, choose **Enhance>Adjust Color>Adjust Hue/ Saturation**, and click the Colorize checkbox. Drag the Saturation slider to 26 and drag the Hue slider until you get a colour you like. When you reach the desired colour, select OK, then **Select>Deselect** and rename and save.

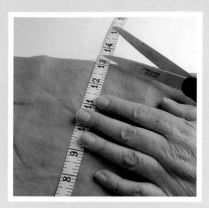

6 If desired, repeat steps 1–5 with another image to have more than one image on your shoe bag.

7 Use the **File>Print Multiple Photos** option to print the images onto a sheet of adhesive fabric at 12.7 x 17.7cm (5 x 7in) in size.

8 Cut a piece of fabric measuring 33 x 81cm (13 x 32in) in size. Fold it in half widthwise right sides together, raw edges even, creating a 43 x 33cm (17 x 13in) rectangle.

9 To make a casing for the cord, lay the folded rectangle on a flat surface in horizontal orientation, fold at the left side. Mark the cord opening in the casing as follows: measure and mark with pins two points on the right short side, one 1cm (½in) and the second 2.54cm (1in) from the top. Machine stitch along the side, leaving a gap between the pins. Machine stitch the long side at the bottom edge, creating a bag. Press the seam flat. Measure, fold over, and use an iron to press the 5cm (2in) top section.

Tips

* **USING AN ALTERNATIVE METHOD**

Adhesive fabric is a great choice when you want to make a neat cutout around a printed image. The glue on the fabric makes it easy to adhere fabric designs to a project without the need for sewing or finishing the raw edges. For a more finished look, use a sewing machine set on zigzag to create a satin stitch around the edges of the image.

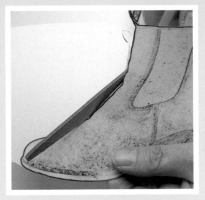

10 Turn under a 50mm (¼in) hem at the raw edge and machine stitch to secure.

11 To thread cord through the casing, secure a safety pin to one end of the length of cord. Insert the pin in one hole and thread through until the safety pin exits the second hole. Remove the pin, pull the ends, and knot together. Turn to the right side and iron flat.

12 To prepare the printed image, use scissors to trim around the image printed on the adhesive fabric. Decide where on the bag you would like to position the image or images.

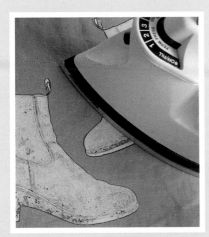

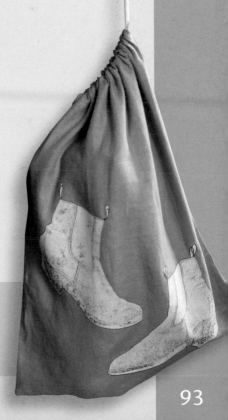

13 Position and affix the images to the bag as desired, following the manufacturer's instructions. The adhesive fabric we used required using a hot iron on the wool (no steam) setting.

Fancy footwork

This project would make a great gym or overnight bag for your kids.

Novelty Paper Projects

✳ Jigsaw Puzzle Picture Frame **96**

✳ Refrigerator Magnets **100**

✳ Heart-Shaped Earrings **104**

✳ Key Ring with Beaded Fringe **108**

✳ Portrait Badges **112**

Jigsaw Puzzle Picture Frame

Jigsaw or flip puzzle paper can be used to transform any photo or print into jigsaw puzzles. The paper is incredibly easy to use. Print one side of the paper, remove the protective backing (to reveal the adhesive), then fold the print in half to form a thick jigsaw puzzle with breakaway pieces! Here, we've used the paper to create a one-of-a-kind picture frame.

Materials

* Family photo or other image in digital format
* Sheet of puzzle paper
* Plain, white paper
* Raw wood frame
* Artists' gesso
* Acrylic paint
* Metal frame corners
* Piece of costume jewellery or metal accent, as desired
* Piece of cardboard or matte board for backing
* 2 picture hooks and picture wire (optional)

Tools

* Ruler
* 320-grit wet/dry sandpaper (or similar)
* Lint-free cloth
* 2 paintbrushes, each 2.5cm (1in) wide
* Glue
* Utility knife with a breakaway blade
* Dimensional adhesive or glue dots

1 Open up your chosen image in Photoshop Elements. For this project I've used a photo of my grandmother. She was a wonderful woman – an artist – and she always dressed beautifully. This is a favourite photo of her in the coat she always wore in winter. Perhaps you, too, have a special family photo.

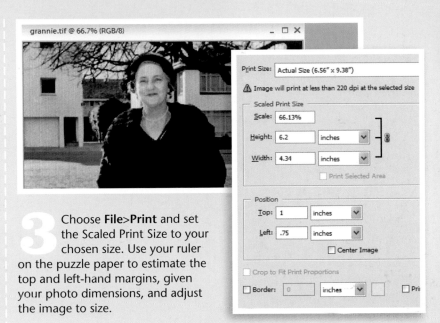

grannie.tif @ 66.7% (RGB/8)

Print Size: Actual Size (6.56" x 9.38")

⚠ Image will print at less than 220 dpi at the selected size

Scaled Print Size

Scale: 66.13%

Height: 6.2 inches

Width: 4.34 inches

☐ Print Selected Area

Position

Top: 1 inches

Left: .75 inches

☐ Center Image

☐ Crop to Fit Print Proportions

☐ Border: 0 inches ☐ Pri

2 Measure the size of the jigsaw puzzle on the puzzle paper to determine what size to print the image. It is best to print the photo a little larger than the puzzle dimensions in case the printer doesn't print in exactly the right position on the paper.

3 Choose **File>Print** and set the Scaled Print Size to your chosen size. Use your ruler on the puzzle paper to estimate the top and left-hand margins, given your photo dimensions, and adjust the image to size.

4 Make a Test print using plain paper. When you're sure that the image will print in the correct position on the puzzle paper, print it. Let the printed image dry thoroughly.

5 Flip the puzzle over and remove the backing paper to reveal the adhesive backing.

6 Carefully fold the puzzle in half, edges even, pressing the layers together. Set aside.

97

7 To prepare the frame, use sandpaper to remove any rough edges and to create a smooth surface for painting. Use a lint-free cloth to remove dust from all surfaces.

8 To apply the gesso, use a 2.5cm- (1in-) wide brush and paint an even coat on all surfaces of the frame. This seals the wood and provides a receptive surface for the paint. Let the gesso dry.

9 Use a clean, 2.5cm- (1in) wide brush to apply a smooth coat of acrylic paint to the frame. Let the paint dry thoroughly, preferably overnight.

10 To create the distressed finish on the frame, use fine sandpaper to sand off paint on random surfaces of the frame, including the edges. Use a cloth to wipe off the dust. The sanding will remove some of the top layer of paint to reveal the layer of white gesso or even wood beneath. This gives the appearance of wear and age – an attractive patina with rustic style.

11 To prepare the puzzle pieces, break off the pieces at the edge of the central image.

12 To decorate the frame, arrange the puzzle pieces on sections of the frame as desired. Here, the subject has been positioned at the bottom left-hand corner with the other pieces being placed in a pleasing configuration. When satisfied with the arrangement, use glue or glue dots to adhere the pieces to the frame.

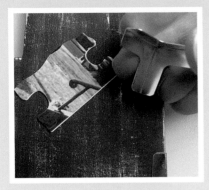

13 To finish, position and affix the frame corners to the bottom right-hand and top left-hand corners of the frame, or as desired.

14 To decorate the frame, position and affix a piece of jewellery or a fun metal accent to the top right-hand corner of the frame using glue.

15 To fit the photo in the frame, use a ruler and a straight edge to trim the photo to fit the frame opening. Repeat to make a backing using a sheet of cardboard or matte board. Place the backing in the frame opening and secure.

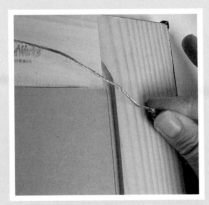

16 Optionally, to hang the frame, turn the frame over to the back and affix hooks to the opposite sides, approximately a quarter of the way down from the top edge. Thread and knot one end of a length of wire to each hook.

You've been framed!

The jigsaw puzzle pieces can also be used to decorate mirror frames and the surfaces of jewellery boxes.

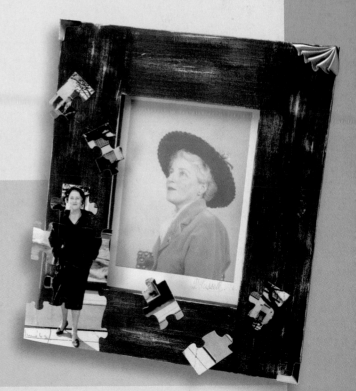

Refrigerator Magnet

Ink-jet magnet paper is a water-resistant paper that comes in a matte or glossy finish. Its sturdy magnetic backing makes it perfect for creating business cards, signs, and refrigerator magnets. Here, we've used it to create a small vacation scrapbook page that is displayed for all to see on a refrigerator.

Materials

* Lazy Days of Summer Memory Page Template from the download site, or use your own scrapbook template in digital format
* Vacation photos in digital format
* Sheet of ink-jet magnet paper
* Pieces of sea glass
* Small seashells

Tools

* Rotary cutter or pair of scissors
* Mat
* Ruler
* Hot-glue gun and glue sticks

1 Go to the download site (Cottagearts.net) and open a Memory Page Template to use for the magnet. We used Lazy Days ScrapOver CottageArtsNet.png.

2 Choose **File>Open** and browse your system for usable photos. For this page template you'll need four photos. Select **File>Open**. Click the Move tool on the Toolbar. Click on the first photo and drag it onto the template in the photo bin. Repeat with the remaining photos.

3 Use the Move tool to resize each photo, keeping the photos in proportion by holding down the Shift key while dragging inwards or outwards to fit the template. Display the Layers palette, right-click on the photo layers and choose Rename. To identify each layer, key names Photo1, Photo2, etc.

4 Click Layer 0 in the Layers palette – this is the bottom-most layer. Drag it upward until it is above the Photo layers. The photos are now perfectly sized and will each have an artistic edge.

5 To select a font, click the Text tool on the Toolbar and make your desired choice. We used Selfish. Set the size to 34 or more. To select your text colour, click the Text Color box and, using the Color Picker tool, click on any colour in the layout. We chose a lighter shade of the ivory in the polka dot background.

Tips

✳ JOURNALING

Jotting down memories, sayings, lines of poetry, or songs in a diary or notebook can be a very useful and immediate resource for making projects like this refrigerator magnet. When you get to step 6 and need to find some inspirational text to add, you can go to your personal archive and find something that suits the images or photos you are using. With photographs of your family on vacation, you can add your memories of what happened that day.

6 To begin, select the top layer in the Layers palette and click on the image where you want the text to appear. Type your text and adjust its position and size as necessary.

7 Save your file as a Photoshop format (PSD) file to retain layers by selecting **File>Save** and choose the format PSD. Choose **File>Print**. In the Print Preview dialog, set the Print Size to Actual and set the Width to 20cm (8in) and Position to 0.197in. Select the Center Image checkbox, then select **Print>Properties** to set up the Paper Type according to the magnet paper manufacturer's instructions.

8 To print your image, place the ink-jet magnet paper in the printer, making sure that it prints on the paper side.

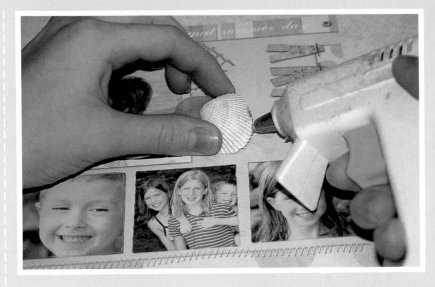

9 Use a rotary cutter or scissors, mat, and ruler to trim the scrapbook page layout to the edge.

10 To decorate the scrapbook page, use dabs of glue from a hot-glue gun to adhere sea glass and sea shells in position, as desired. Place the finished magnet on the refrigerator.

Tips

❋ SMALLER-SIZE MAGNETS

The magnet created for this project is quite large. Should you wish to do so, print multiples of the magnet at a smaller size. Choose **File>Print Multiple Photos** and print more than one copy of the magnet on one sheet of magnet paper. These magnets make a wonderful gift for family and friends.

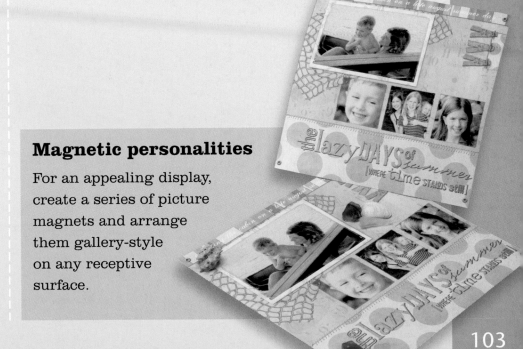

Magnetic personalities

For an appealing display, create a series of picture magnets and arrange them gallery-style on any receptive surface.

Heart-Shaped Earrings

Embossing paper lets you heat-emboss your printed image. After the paper has been printed, its slow-drying ink remains receptive to the embossing powder, which, when poured over the surface and heated, produces a shiny, dimensional effect. For this project we've used some heart-shaped images to make two pairs of earrings, but use your imagination to create earrings of your own design.

Materials

* Heart-shaped images from the download site, or use your own images in digital format
* Sheet of embossing paper
* Plain, white paper
* Clear embossing powder
* Small, adhesive faceted jewels
* Glue (E6000 or similar)
* Earring posts

Tools

* Small scissors
* Tweezers
* Embossing heat gun
* Nail file or emery board

Heart Charm Pink.png @ 100% (Layer 0, RGB/8*)

1 Go to the download site (Cottagearts.net) and browse the images. Open the image you want to use in your software. We chose pink and blue hearts.

2 Create a new document by choosing **File>New>Blank File**. Configure it to a 21.59 x 27.94cm (8½ x 11in) rectangle and the resolution to 300ppi. Click OK.

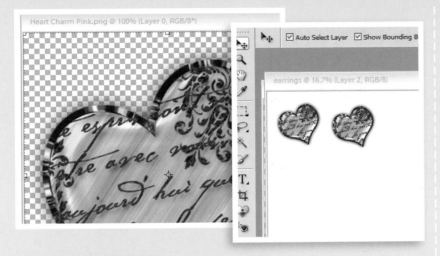

3 Select the first of the heart images and click **Select>All**, then **Edit>Copy**. Select the new blank file and choose **Edit>Paste**. Repeat and choose **Edit>Paste** a second time to add a second heart to the document. Add two more pink hearts if desired if you are making two pairs of earrings.

4 Repeat step 3 and select and copy the second heart. You will need two hearts for each set of earrings.

5 Close the heart images and work on the large image with the multiple hearts in it. Choose **View>Grid** to display a grid and then click on the first heart. Use its sizing handles to reduce its size to approximately 50% of the original, and so that it will print at about 1.6cm (⅝in) in size.

6 Repeat step 5 and resize the hearts to the same size. Arrange them on the page to minimize the amount of paper required to print them.

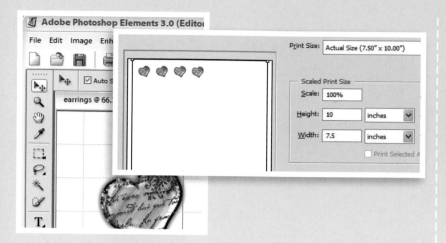

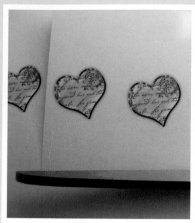

7 To print the document, choose **File>Print** and click the Page Setup button to configure the printer options. Use Super Color embossing paper and the setting required for printing Photo Paper with Best resolution. Print the images onto the paper.

8 Carefully remove the printed paper to avoid smearing the ink. Use scissors to trim roughly around each heart, leaving a wide margin around the perimeter for easy handling.

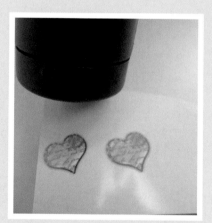

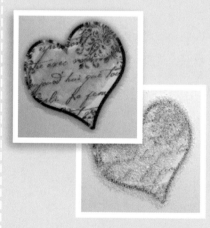

9 Lay a sheet of clean, white paper on a flat surface. Hold the heart with a pair of tweezers and dust the entire surface with clear embossing powder. Tap the heart paper lightly against the countertop to remove any loose powder. The powder will stick to the wet ink. Return the excess powder to the container.

10 To melt the powder, use the embossing heat gun, moving the nozzle evenly over the surface, until the powder melts and turns shiny. While the surface is still hot, pour a second coat of embossing powder over the surface, using the heat gun to melt the second layer.

11 Above, the heart on the left shows embossing powder that is correctly melted. The heart on the right is not yet heat-set.

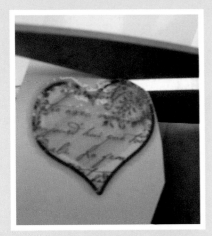

12 Use scissors to carefully and neatly cut around the heart shape.

13 Use a nail file or emery board to smooth down the edges of the heart.

14 Use tweezers to remove a faceted jewel from a sheet of adhesive jewels and position and press it on the heart shape, as shown.

15 With a strong adhesive, adhere the heart shape to the earring post. Set aside to dry. Your project is now complete.

Heartwarming gift

These earrings make a perfect present for your mum, sister, or close friend. Print as many elements as you like to make several pairs.

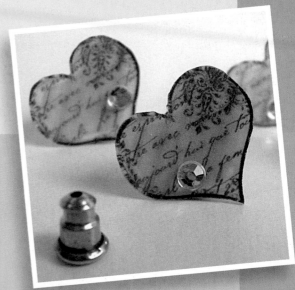

Key Ring with Beaded Fringe

Shrink plastic is a fun material. After it has been printed on, it is heated. This heating process causes the plastic to shrink, reducing and thickening its dimensions. Shrink plastic takes on a rigid quality that makes the material ideal for craft projects that require resistance to wear and tear, like the key ring we've created here.

Materials

* Photo of your choice in digital format
* Sheet of shrink plastic
* Key ring
* 5 jump rings
* 5 small beads
* 5 head pins, 2.5cm (1in) in length
* Acrylic varnish (optional)

Tools

* Scissors
* Ruler
* Pencil
* Hole punch
* Regular oven
* Disposable foil pan
* Oven mitt
* 2 pairs pliers, needle-nose and standard
* Safety glasses
* Wire cutters
* Paintbrush (optional)

1 Open your photo in Photoshop Elements and crop it to size using the Crop tool. Make it a rectangular shape, but leave plenty of room at the top and bottom of the image to accommodate punch holes.

2 Lighten the image by choosing **Enhance>Adjust Lighting>Brightness/Contrast** and increase the brightness. The colours will be intensified when the image is shrunk, so starting with a lighter image works best.

3 Select the Brush tool and a light or white Foreground colour. From the brush shapes pull-down menu, choose a Dry brush and set the size to a large value, depending on the resolution of the image. We made ours 450 pixels.

4 Click on the image around the subject to paint out the background. The lighter the background, the better the final result will be. Use the dry brush for a softer, uneven look.

5 Choose **File>Print** and set the Height and Width to approximately 15 x 10cm (6 x 4in). Position the image on one side of the paper so that you can use the rest of the paper for another project.

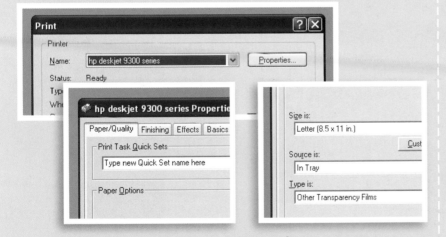

6 Select **Print**, click **Properties**, and set the Paper Type and Quality to those recommended by the manufacturer. There are wide variations in results among the different brands, so be sure to following the printing instructions exactly.

Tips

❋ DIFFERENT PLASTICS

Shrink plastic comes in clear, white, and off-white. We found a wide variation in how well these plastics work and the printer settings required to obtain optimal results. The plastic works best with lighter images and with printer settings that use less ink, such as Transparency or high-gloss Photo Paper.

7 Print the page and let the ink dry thoroughly, preferably overnight. Take care handling the plastic even when it is dry.

8 To make the key tag, use scissors to cut out the image in a rectangular shape. At the corners, trim the points in a curve so that the finished tag won't have sharp corners.

9 At the bottom of the image, use a ruler and pencil to mark points at even intervals. At the top of the image, mark the mid point. Use a hole punch to make a hole at the marked point at the top and five holes at the marked points along the bottom. The holes must be made before heating the plastic as they will be too hard afterward.

10 Preheat the oven. Place the printed image on a disposable foil pan and bake according to the manufacturer's instructions. In some cases, the piece should be baked face down, so it is important to consult and follow the printed directions.

11 Check the plastic as it heats. As it shrinks it will curl up and then flatten out. When flat, put on an oven mitt, remove the pan from the oven, and set it on a heat proof surface. Be careful handling the plastic, as it will be very hot and can burn you.

12 Put on safety glasses. Hold a head pin and thread on one bead. Use wire cutters to trim the head pin to 1.25cm (½in) beyond the bead. Hold the free end of the wire while cutting to avoid injury. At the top of the bead, use needle-nose pliers to bend the wire to 90 degrees. Repeat with the other head pins and beads.

13 To decorate the key tag, add a beaded fringe, as follows. To form a hanging loop, hold the end of the wire in the ends of the needle-nose pliers and twist the wire. Use two sets of pliers to open a jump ring by twisting the ends in opposite directions. Thread on one bead, thread one end of the beaded loop through the jump ring, and insert the end through one of the five holes. Then twist the jump ring to close it. Repeat to attach bead loops to the remaining holes at the bottom edge of the tag.

Tips

✳ EXTRA PROTECTION

To protect your key tag from wear, use a paintbrush to apply a coat of acrylic varnish to the printed side, following the manufacturer's instructions.

14 To finish, open the jump ring on the key ring attachment and thread it through the top hole in the key ring. Twist the jump ring closed.

All ready to go!

Why not make a unique key ring for each member of your family? Confusion over whose keys belong to whom will be a thing of the past!

111

Portrait Badges

Two materials that you might not think of using for craft projects are vellum and office transparencies. Vellum is translucent, so it's a great paper to layer over a coloured or patterned backing. Office transparencies, which are typically used for presentations on an overhead projector, are – as one might expect – completely transparent and can be used to great effect. We've combined both these materials in this project.

* Portrait-style photos to be scanned or in digital format
* 1 or more sheets of printable vellum paper
* 1 or more sheets of transparency for ink-jet printers
* Sheet of matte board with one white side
* 4 small brads for each badge
* Self-adhesive pin back for each badge

* Pencil
* Ruler
* Cutting mat
* Utility knife
* Scissors
* 7mm (⅜ in) hole punch

1 Select photo images by scanning available photographs to use for the name badges or by downloading them from your digital camera. Images with lighter backgrounds work better than those with dark backgrounds.

2 Make a square selection on your photo using the Rectangular Marquee tool with the Mode set to Fixed Aspect Ratio and the Width and Height set to 1. Be aware that the bottom half of the photo will be partially covered by the transparency, so make sure that it won't cover any important detail.

112

3 To crop the image, choose **Image>Crop**. Repeat for the remaining images.

4 To make all the photos black and white, select each in turn and choose **Enhance>Adjust Color> Remove Color.**

Tips

✳ PRINTING ONTO VELLUM

Vellum can be tricky to print onto. It's essential that you use the Vellum or Transparency option on your printer. If neither setting is available, use Draft so that you don't get a lot of ink on the paper. Let the ink dry thoroughly before using it.

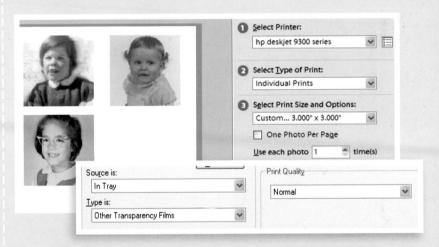

5 To recolour the images to a single colour, choose **Enhance>Adjust Color>Adjust Hue/Saturation** and check the Colorize checkbox. Drag the Hue slider until you find a colour you like. Use the Saturation and Lightness sliders to fine-tune the result. If the Adjust Hue/Saturation option is disabled, choose **Image>Mode>RGB Color** and try again.

6 To print all photos on one page, choose **File>Print Multiple Photos.** Under (2) Select Type of Print, choose Individual Prints, and under (3) Select Print Size and Options, choose 7.62 x 7.62cm (3 x 3in). Uncheck 1 Photo Per Page checkbox. Go to **Page Set Up>Printer>Properties** to choose the Transparency film option and leave the quality as set by your printer driver. Print the photos onto a vellum sheet.

113

7 Create a new Letter size document at 300ppi, and select a foreground colour to use for your type. Use the Type tool to type the words, *'Hello, my name is'* into the image. Repeat this text once for each person for whom you are making a name badge. Type the individual names underneath.

8 Size the text so that you can cut it into a 7.5cm (3in) wide strip later on. We used a grid (**View>Grid**) set to display 2.5cm (1in) sections against which to check the measurements. Print the document onto transparency paper and choose **Print Size>Fit On Page**.

9 Using a pencil and ruler, mark out four 7.5 x 7.5cm (3 x 3in) squares on a sheet of matte board.

10 Lay a cutting mat on a flat surface, positioning the matte board on top. Use a utility knife and ruler to cut out the marked squares on the board. For clean, accurate cuts, score the line, then run the blade along the scoreline two or three more times to cut through the board. Set aside.

11 Use scissors to cut out the portraits on the vellum paper to 7.5 x 7.5cm (3 x 3in) squares.

12 Use scissors to cut out the words from the transparencies. Cut them to a width of 7.5cm (3in) and the height of the text plus 3mm (⅛in).

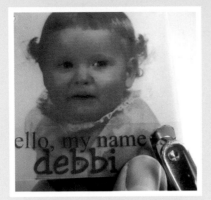

13 Place the vellum over the matte board, lining up all the edges. Use a small (7mm/⅜in) hole punch to make holes through the vellum and matte board at the top corners, and secure the layers using a small brad.

14 Holding the transparency in place over the bottom of the matte board and image as a guide, punch holes through the three papers at opposite ends, and secure the layers using a brad.

15 Remove the backing paper from the adhesive foam on a pin back and adhere it to the back of the badge.

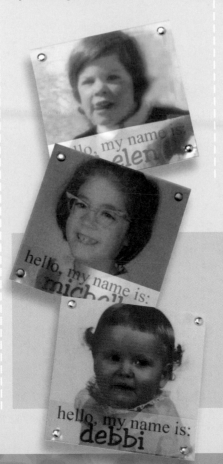

Tips

✳ BETTER VELLUM PRINTING

Scraperfect makes a Perfect Printing Pouch for vellum to help ink adhere to plain and textured vellum papers. Rub the paper with the pouch, shake to remove excess powder, then print on the paper. The results are excellent.

✳ CHOOSING THE RIGHT TRANSPARENCIES

There are two types of transparencies available: one for ink-jet and another for laser printers. If you have an ink-jet printer, you must use that type. Otherwise, your ink won't dry when printed on laser transparencies! Ink-jet transparencies have a texture that helps the ink adhere, whereas laser transparencies are smooth on both sides.

Claim your badge

These badges are the perfect ice-breakers! They make it easy at parties to introduce people to one another.

Heat Transfer Projects

✻ Baby Bibs and Bodysuits **118**

✻ Christmas Ornament **122**

✻ Cotton Apron **126**

✻ Pop Art T-Shirt **130**

✻ Chair Cover **134**

✻ Doll and Teddy Clothes **138**

✻ Sewing Basket **142**

✻ Roller Blind **146**

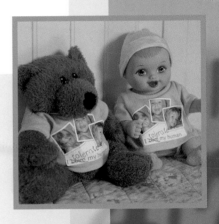

Baby Bibs and Babygrows

In this project, we use transfer paper to apply words and images to babywear. Using the same motifs on all pieces allows you to create a coordinated ensemble even though the bibs and babygrows do not match. When you're applying images to dark or coloured fabrics, dark fabric T-shirt transfer paper creates an opaque background that prevents the underlying colour from showing through. You can apply art to clothing using this special paper provided that the clothing or the fabric you're using is capable of being ironed at high temperatures.

1 Open your chosen images. We used some clip-art images of safety pins and charms featuring the word 'Baby' from Cottagearts.net. The two motifs are printed so the charm looks as if it is hanging from the pin. You'll also recolour the images to coordinate the colours of the garment.

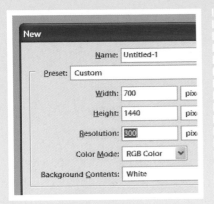

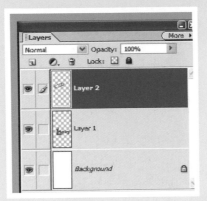

2 Choose **File>New>Blank File** to create a document that's large enough to accommodate the pin and the baby charm. We made ours 21.59 x 27.94cm (8½ x 11in) at 300ppi in size with a white background.

3 Display the Layers palette and drag the layer containing the illustration from the 'Baby' charm image into your new document. Then repeat and drag the layer with the pin from the pin image into the document. Reduce the size of the pin and rotate it to the right. Replace it so that it is positioned over the loop in the charm.

4 Click on the layer containing the pin image and choose the Eraser tool in the Tool palette. Choose a very small brush with a soft edge. Set its opacity to 75%. Zoom in and erase the area where the pin overlaps one loop of the charm to give the appearance that the charm is hanging from the pin.

5 To recolour the image, choose **Layer>Flatten Image**. Now choose **Enhance>Adjust Color>Replace Color** and click the Eyedropper tool. Click on some pink colour in the image. Click the Eyedropper with the + symbol beside it and continue to click on the pink colour until it is all selected. You will see this as white in the Replace Color dialog.

6 Click in the Result Color box and select a colour to use to replace the pink colour. Crop closely around the image. Repeat this, if desired, for another combination of pin and matching coloured charm. It's best to start with a colour that is close to the one you want to end up with.

119

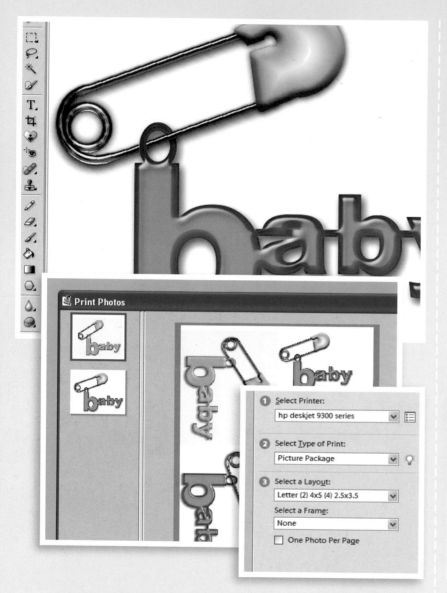

Tips

✱ BABY CLOTHING

This project makes an ideal shower gift for a baby. You can apply the technique to create a matching hat, mittens, booties, and baby's cot blanket. Decorate everything in the same way or vary the placement and number of motifs used on each piece. Use the pin design by itself or combine the lettering with different-sized pins. Choose gender-neutral colours such as yellow, cream, or pale green for background colours. They will look lovely.

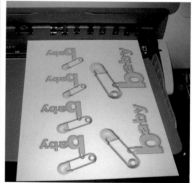

7 To print multiples of an image at different sizes, choose **File>Print Multiple Photos**. From the Select Type Of Print list, choose Picture Package. From the Select A Layout box, choose Letter (2) 4 x 5 (4) 2.5 x 3.5. Drag and drop images from the left of the page into boxes on the layout page.

8 Print the images onto transfer paper suitable for dark clothing, using the manufacturer's recommendations for paper and printer settings. This paper has a backing on it and doesn't require the image to be mirror-printed. Allow the ink to dry.

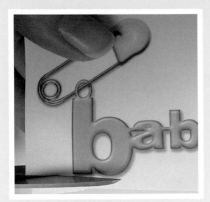

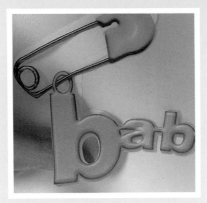

9 Use scissors to cut carefully around the image. If desired, use a utility knife to cut away the paper inside the letters – for example, B and A – and inside the pin for a more professional result.

10 Carefully peel away the backing material from the images. Be extra careful with hollow shapes.

11 Empty the iron of all water, then reheat your iron with the steam button turned off. Use a flat surface padded with a protective cloth – not an ironing board. Iron the fabric to remove any moisture.

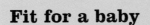

12 Position the image, as desired, and cover with the ironing sheet provided or a lightweight, cotton cloth. Follow the manufacturer's instructions for adhering the image. This will involve ironing with a hot iron. Carefully lift the ironing sheet from the project and check to make certain that the edges are bonded to the garment.

Fit for a baby

Your baby will have the admiring glances of other mothers in this outfit. And don't worry, the items can be washed.

Christmas Ornament

This is a really fun and straightforward project that will put you in the festive spirit as the Christmas season approaches. Gather the children around a large table and make personalized decorations for the tree. Here, a ball-shaped ornament has been decorated with special, heat-activated adhesive backing printed with a portrait. The material adheres to practically any surface. In this design, miniature portraits of the family have been affixed to the interiors of metal bottle caps. Make several for yourself and give them as gifts to your family and friends.

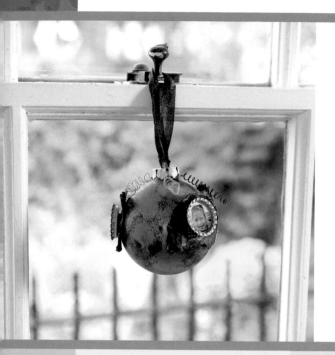

Materials

* Selection of head-and-shoulders photos in digital format
* Sheet of adhesive paper
* Clear, glass Christmas tree ornament
* Acrylic paint in black, gold, and light blue/green
* Scraps of red Mulberry paper (or similar)
* Scraps of gold adhesive mesh
* 60cm (24in) each of 22-, 24-, or 26-gauge, black/green-coated craft wire
* 20cm (8in) coordinating red ribbon
* 3 metal bottle caps

Tools

* Sponge
* Dimensional adhesive
* Knitting needle and lollipop stick
* Wire cutters
* Iron
* Scissors

1 Open the images in your software that you want to use. You can use up to three different photos per ornament. Select the Elliptical Marquee tool and hold the Shift key as you select around the face of the person you'd like to feature. Choose **Image>Crop** to crop to that shape. Choose **Select>Inverse** and, with the Background colour set to White, press Delete. Repeat with the remaining images.

2 To size each image so that it prints at 2.54cm (1in) size, choose **Image**>**Resize**>**Image Size** and set the width and height to 2.54cm (1in) and the resolution to 200ppi. Click OK. Repeat for the remaining photos.

3 Print the images by choosing **File**>**Print Multiple Photos**. From the Select Type of Print list, choose Individual Prints, and from the Select Print Size and Options list, choose Custom and then set the photos to print at 2.54 x 2.54cm (1 x 1in). Select the number of times you wish to print each photo. Select **Page Setup**>**Printer**>**Properties** and set the printer preferences to those recommended by the manufacturer for the paper. Print the sheet of images. Set them aside.

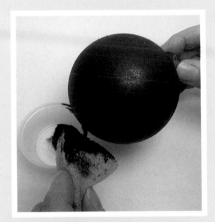

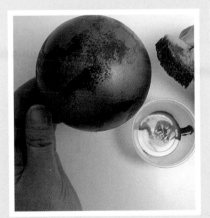

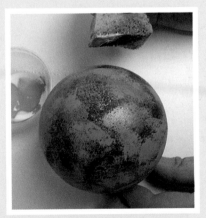

4 Remove the metal cap from the Christmas ornament. Set aside. Using a sponge, dab black paint over the glass ornament. You should get good coverage with just one application of paint. Let the paint dry. Clean the sponge before applying the next colour.

5 Using the sponge, dab gold paint over the black paint, but don't cover it entirely. The black paint should show through in areas. Let the paint dry. Clean the sponge before applying the final colour.

6 Using the sponge once again, dab blue/green paint sparingly over the painted ornament. Make sure that plenty of the black and gold paint still shows through. Let the paint dry completely.

123

7 Tear the Mulberry paper or other, similarly textured paper so that you get an attractive, torn edge. To achieve a suitably ragged tear line, use a paintbrush to dab drops of water along a line on the paper where you wish to tear.

8 Hold the paper firmly in both hands and pull it to tear it along the line you marked. Repeat until you have three squares, each approximately 5 x 5cm (2 x 2in) in size.

9 Crumple up each square of paper in your hand to form a small ball and open them up again.

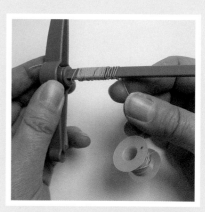

10 Cut three small squares of gold adhesive mesh, each measuring approximately 2.5 x 2.5cm (1 x 1in). Position and press on top of each red square.

11 Adhere the three red squares at equal intervals around the ornament, using a dimensional adhesive.

12 To make a long coil, wrap a length of black wire tightly around a wire tool or knitting needle. Slide off the coil and set aside. Repeat using the blue/green wire, wrapping this around a lollipop stick. Slide the wire coil off the stick and set aside.

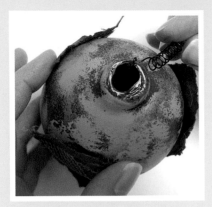

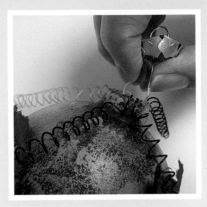

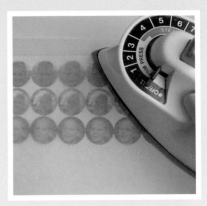

13 Use wire cutters to cut each coil into two or three lengths and pull the ends to stretch. Position one wire end of each coil on the neck of the ornament, and adhere in place using a dot of dimensional adhesive.

14 Replace the metal cap on the neck of the Christmas ornament, trapping the ends of the coils. Thread a length of ribbon through the ornament hoop and tie the ends together in a knot.

15 Place the sheet of parchment paper supplied by the manufacturer over the printed paper. Following the manufacturer's directions, use an iron set at the recommended heat to melt the adhesive. Keep the iron moving for about 10–15 seconds to avoid burning the paper.

16 Use scissors to cut out the photos, then remove the backing paper to expose the sticky reverse. Adhere the images inside the bottle caps then stick the bottle caps to the ornament using dimensional adhesive, placing them inside each square. Your decoration is now complete!

Having a ball

For a truly personalized Christmas tree, make a pretty decoration featuring every member of your family.

Cotton Apron

There are different styles and sizes of aprons available, depending on your personal taste. For this project, a standard restaurant-supply apron, the kind with deep pockets, was decorated with images printed onto T-shirt transfer paper and heat-transferred to the front of the apron. The paper is opaque white and dark fabric won't show through images printed on it.

Materials

* Kitchen items to photograph, or use images from the download site
* 3 sheets of dark T-shirt transfer paper
* Small, server apron (available from restaurant-supply stores)

Tools

* Scissors
* Tape measure or ruler
* Iron

1 Photograph your favourite kitchen items or use the images whisk.tif, bowl.tif, and eggs.tif from the download site (http-design.com). If you are taking your own photos, shoot the objects against a white or neutral background and photograph them from the side. We composed a still life of baking flour with an egg cracked into it for an unusual image.

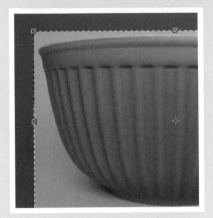

bowl.tif @ 33.3% (RGB/8)

Image Size

Pixel Dimensions: 1.51M (was 2.97M)

Width: 900 | pixels

Height: 587 | pixels

Document Size:

Width: 6 | inches

Height: 3.911 | inches

Resolution: 150 | pixels/inch

2 Open all the images in Adobe Photoshop Elements. Select the Crop tool and use it to crop each image close around the object.

3 Plan the relative sizing of each image. Measure the available space for printing on your apron. Keep in mind that a sheet of paper is 21.59 x 27.94cm (8½ x 11in) as you consider the size of the images you want to print. You can size the objects to suit your preferences. To size the first image, choose **Image>Resize>Image Size** and set the Width and Height to the desired size, keeping the size of the final image in mind. Set a printing resolution of 150ppi. Allow an extra 1.25cm (½in) for cropping around the image.

whisk.tif @ 50% (RGB/8)

Image | Enhance | Layer | Select | Filter | View | Window

Rotate — 90° Left
Transform — 90° Right
Crop — 180°
Divide Scanned Photos — Custom…
Resize — Flip Horizontal
 — Flip Vertical
Mode —
Free Rotate Layer
Layer 90° Left

4 If you want to create a pattern of your images and decide to use them in reverse, choose **Image>Rotate>Flip Horizontal**. This is not an effect you can use for text-based images. This isn't required for the project shown here, but keep it in mind if you'd like to create a layout of your own design.

5 To ensure that the outsides and insides of the images are white, choose the Magic Wand tool to select the area around the first of the objects. There are other selection tools you might use, but this is the best. In the case of the whisk, select the areas in between the wires, too.

6 Add a small feather to the selection by choosing **Select>Feather** and set the value to 2. Set the Background colour to White and press Delete to remove the image background.

7 Repeat step 6 for the remaining two images so that all the images have a plain, white background.

Tips

✻ ADAPT AN APRON TO YOUR HOBBY

Handy for crafters, knitters, gardeners, and even handymen, the apron can be personalized, using photos of objects typically used for that particular task. Take profile shots of the objects for an interesting presentation. For example, for a gardener, you might take photos of garden tools, a terracotta pot, and a few bulbs or colourful seed packages arranged in a pleasing design.

8 You can now print each image at its actual size, which should also be its optimal size. To do this, choose **File>Print** and, from the Print Size list, choose Actual Size. Use the Page Setup dialog to set the paper orientation to Landscape if necessary to allow plenty of paper for the object to print on. Set the printer Properties to the Paper Type and Quality recommended by your paper manufacturer. Print each image onto a sheet of transfer paper.

9 Use scissors to cut around the perimeter of each of the objects on the paper. Leave a narrow, white margin around the objects.

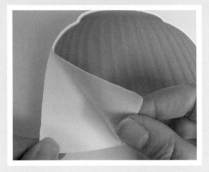 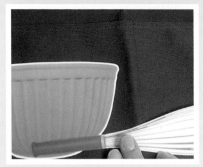 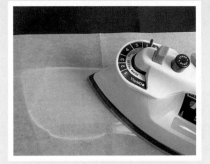

10 Carefully peel away the backing paper from each image.

11 Position the images where you want them on the apron.

12 Adhere the images following the manufacturer's instructions for the paper. For the paper we used, we emptied all the water from the iron, then ironed the fabric to remove any residual moisture. Then we laid a sheet of thick tissue paper (supplied by the manufacturer) over the top of the images to protect them from the surface of the iron. Then we ironed the images on the apron.

Tips

✳ WHAT'S IN YOUR POCKET?

An alternative to placing images on the front of this apron is to place them so they sit just inside the pocket making it look as though they are in the pocket. When printed and trimmed, adhere carefully in place.

All tied up!

This apron will be an essential item of clothing for cosy days spent baking in the kitchen. Why not use a photograph of your favourite chef on your apron for inspiration?

Pop Art T-Shirt

There is a wide range of T-shirt transfer material to choose from. For this project we've used glow-in-the-dark transfer paper, which gives it added style. The paper works in much the same way as transfer paper for dark shirts. Print on the paper, remove the backing sheet, and iron the image onto your project. Here, we've created a fun, Pop Art effect on a T-shirt.

David.psd @ 45% (RGB/8)

1 Open a photo to use – a portrait is a good choice. Crop it closely to cut out a lot of extra background detail.

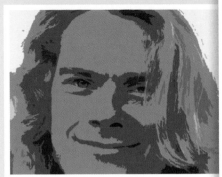

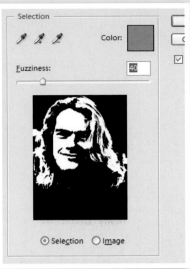

2 Choose **Filter>Artistic> Cutout** and set the Edge Simplicity value to 1 and the Edge Fidelity value to 2. Experiment with different values for the Number of Levels to see what gives you the best result. We used a value of 4.

3 To colour the image, choose **Enhance>Adjust Color>Replace Color**. This dialog lets you select a colour in the image and then change it. Click on the + Eyedropper tool, then click on a colour in your image to replace it. Click on the normal Eyedropper to deselect the tool.

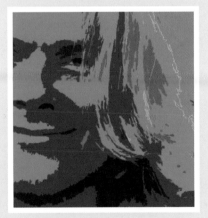

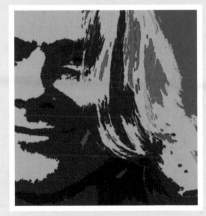

4 At the bottom of the dialog is the Hue slider – use this to choose another colour and adjust the Saturation and Lightness values to suit. As an alternative, click the Result box to open the Color Picker and choose a colour from the palette. We selected blue.

5 Continue to select and replace colours until you have a result that you like. Save the finished image reference as, for example, Portrait1.tif. You're now ready to start on the next image.

6 Repeat the recolouring process on the second image using some of the same colours you used in the previous image, but use them in different combinations. Add some new colours, too, but make sure that they work together. When you're done, save this image as Portrait2.tif.

131

7 Repeat steps 1 to 6 to create two more images. When finished, open all four images and make sure that these are the only photos you have open. Choose **File>Print Multiple Photos**.

8 In the Print Photos dialog, choose a print size that fits all four images on the page in a neat arrangement and select Crop to Fit if this works for the images you've chosen. Print the image onto a sheet of transfer paper.

9 Prewash the T-shirt and dry thoroughly. Use a hard surface like a countertop, not a soft ironing board. Iron the shirt to remove any residual moisture. Let the fabric cool.

10 Use scissors to trim around the print. Carefully remove the backing sheet from the transfer paper.

11 Empty the iron of all water. Preheat the iron on a Cotton setting, steam turned off. Position the printed paper right side up on the T-shirt and cover with the ironing sheet provided. Use firm pressure to iron the paper to the shirt. Keep the iron moving, pressing the edges and corners to make certain that they adhere. Iron for 1½ or 2 minutes, or according to the manufacturer's instructions.

12 To finish, use a soft cloth to rub the ironing sheet for a few seconds. Lift the sheet off the transfer.

A multi-faceted project

This project can be easily customized to make use of portraits of members of your family, a favourite sports personality, or a movie star.

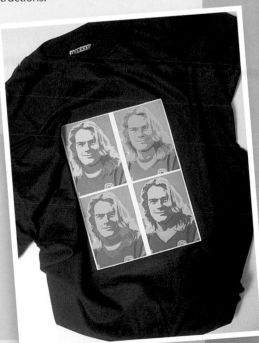

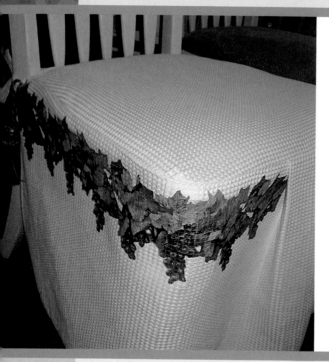

Chair Cover

Whether your chairs are old or new, you may just want to give them a fresh look. If you have a spare weekend, consider making and decorating your own chair covers. It can be a fun project. If you'd prefer a shortcut to avoid the extra work, simply buy slip covers and decorate them. Here, we've used iron-on transfer paper designed for dark fabrics to apply grape wreath motifs to this chair cover, giving it a stylish and relaxed look.

Materials

* 2m (2yd) waffle-weave cotton fabric
* Chair with covered inset seat
* Coordinating cotton sewing thread
* 2 snaps
* 1 or two bunches of grapes to photograph, or use the image from the download site
* Approximately 6 sheets of transfer paper
* 2 tassels

Tools

* Scissors
* Straight pins
* Ruler
* Pencil
* Sewing machine
* Iron

1 To make the seat section, cut a piece of fabric slightly larger than the top chair seat, adding a generous overhang. Pin the fabric to the seat cover or use temporary masking tape to fit it to shape. Use straight pins to secure and shape. Use a ruler and pencil to mark around the seat cover at a fixed distance from the floor. In our case, we marked the seat cover at 40.6cm (16in) from the floor level all around. Cut away the fabric below this mark.

2 Remove the fabric seat section from the chair and machine stitch the pinned and shaped corners to secure their shape.

3 To make the skirt, cut a piece of fabric 49.5cm (19½in) wide, long enough to fit around three sides of the chair, plus an additional 25.4cm (10in). Hem the two 47cm (18½ in) sides by turning under a 2.54cm (1in) seam allowance on each end and machine stitch to secure. Hem one long side, leaving a 2.54cm (1in) seam allowance.

4 Use straight pins to temporarily secure the fabric to the chair seat, starting at the back edge and ensuring that the excess fabric is at the centre front of the chair.

5 Fold a deep pleat in the centre front of the skirt using the excess fabric and using straight pins to secure.

6 Remove the sections from the chair and pin the top of the seat to the skirt, leaving a 2.54cm (1in) seam allowance on the skirt and a 5cm (2in) seam allowance on the seat top.

7 Sew this seam along the pinned line, removing pins as you work. Then sew over the stitches 50mm (¼in) away from the sewn edge to strengthen the seams. Iron the seam, pressing it towards the chair skirt so that the cover fits flush over the chair.

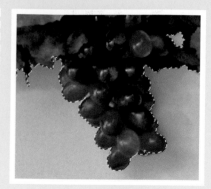

8 To make ties, use leftover fabric to cut four 15 x 5cm (6 x 2in) lengths. Fold each in half lengthwise and sew one long and one short side, leaving a scant 50mm (¼in) seam. Turn the narrow strips right side out.

9 Use straight pins to attach the raw edges of each tie to the edges of the chair cover and machine sew to attach. Sew a snap onto each tie to secure.

10 Photograph a bunch or two of grapes to decorate the chairs or open image grapes.tif provided on the download site (http-design. com). Select the background using the Magic Wand tool. Feather your selection by choosing **Select>Feather**, set a feather of 3, and click OK. Set the Background colour to White and press Delete to remove the image background.

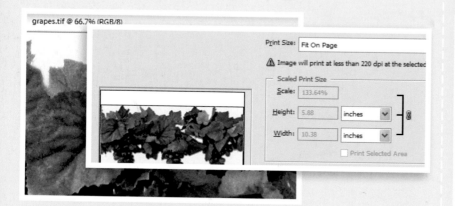

11 To print the image, choose **File>Print**, click Page Setup and set the Paper Orientation to Landscape, and click OK. From the Print Size list, choose Fit on Page. Click Print. Select your printer and click Properties, then set the Paper Type and Print Quality to those recommended by the paper manufacturer. Set the number of copies to the estimated number you need to decorate your chair. We used six copies for this project, each approximately 25cm (10in) in length.

12 Follow the manufacturer's instructions for preparing the paper.

13 Carefully cut around the perimeter of each image. Then, peel away the paper backing.

14 To adhere the images to the cover, follow the manufacturer's instructions. Position the images in a pleasing design, cover the top with a sheet of thick tissue (supplied in the package) on top, and iron the image carefully until it adheres. Continue placing the remaining images on other sides of the chair cover, leaving the front pleat unadorned.

15 To finish, slip the cover over the chair. Thread a tie through the hanging loop of each tassel before securing the chair cover with the snaps.

Tips

❋ ASSEMBLING THE COVER

In this project, you apply the transfers to the chair cover after finishing the sewing part of the project. However, if you wish, you can apply the transfers to the project prior to embarking on step 4. Take care to adhere the transfer beyond the area to be used as a seam allowance. Once the transfers are adhered, handle the fabric with care to avoid creasing the transfers when you sew.

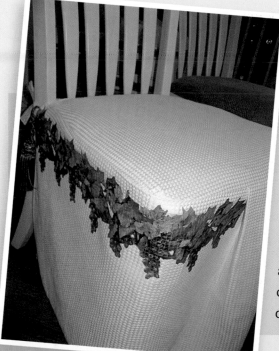

You've got it covered

Once you've made one chair cover, you will know how easy it is to do. Consider making a set of identical covers for each dining room chair.

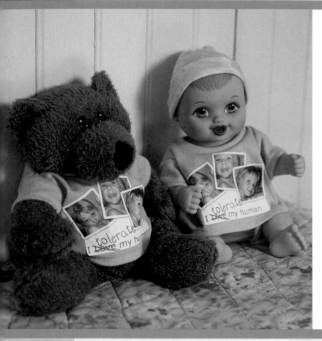

Doll and Teddy Clothes

T-shirt transfers can be used as decorative elements on a shirt of any size, even a very small one. In this project, T-shirt transfer paper suitable for coloured items creates a photo collage for a doll or teddy bear's outfit. If you love children's wear with messages on it, such as 'I Love my Teddy Bear', then this T-shirt design will amuse you.

Materials

* Portraits of the doll or teddy bear owner in a digital format
* Sheet of dark T-shirt transfer paper
* Dolls, and teddy bear clothing, at least 50% cotton fibre.

Tools

* Ruler or measuring tape
* Scissors
* Cotton cloth or heatproof surface to iron on
* Iron

1 Open your chosen images. Crop the first image to a square by selecting the Rectangular Marquee tool, holding the Shift key as you drag the rectangle over the image. When you have a selection you like, choose **Image>Crop** to crop it to a square. Repeat for the other images.

2 Create a new file by choosing **File>New>Blank File** and set it to 25.4 x 19.05cm (10 x 7.5in) with a resolution of 300ppi. Set the Background to White and click OK.

3 Select the first image by clicking **Select>All**. Choose **Edit>Copy** and switch to the new empty image. Choose **Edit>Paste** to paste the image into it. Click the Move tool, rotate the image, and then press Enter to make the transformation.

4 With the image still selected, choose **Edit>Stroke (Outline) Selection**. Set the Size to 50, the Color to White, and set the Location to Outside. Click OK. Choose **Edit>Stroke (Outline) Selection** a second time, set the Size to 6, the Color to Black, and set the Location to Outside. Click OK. This creates a white border around the image.

5 Repeat step 4 and copy and paste the other two (or more) images into your new image. Create a border around each photo in the same way. Move the photos into position to form an attractive layout.

6 Choose a suitable font – Arial or Verdana are nice – and a colour and size that look good with the layout you have chosen. Type the words 'I Love My Human' on the page. Leave enough room above the word 'Love' for an extra word that you will insert in step 8.

7 Choose **Layer>New Layer** and click OK to add a new layer to the image. Select the Pencil tool and another colour, and draw a rough cross though the word 'Love'.

8 In the same colour and with a child's hand-drawn font – ABCKids, perhaps – type the word 'tolerate' and then size and rotate it so that it looks handwritten.

9 Crop the image close all around using the Crop tool.

10 Measure the space available for the transfer on the doll or teddy bear clothes.

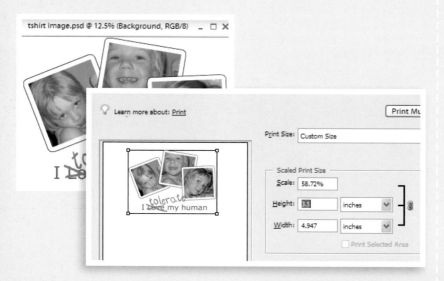

11 Choose **File>Print** and, from the Print Size list, choose Custom size. Set the print measurement to the maximum size you've determined you can use for the height and width. Click Print and then choose Properties to set the Paper Type and Print Quality as recommended by the manufacturer. Print as many copies of the image as you need.

12 Neatly trim around the perimeter of the image to avoid any of the white backing showing up against the clothing.

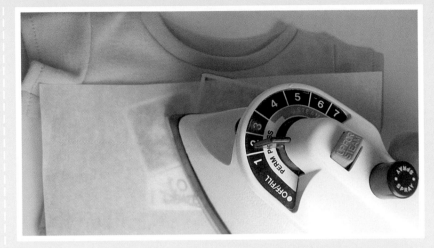

13 Carefully peel away the backing paper from the image.

14 Empty the iron of all water and set to the highest setting, or one recommended by the manufacturer. Cover the image with the ironing sheet provided in the package. Iron it with a hot, but not steam, iron, keeping the iron moving until the image adheres to the clothing.

Tips

✳ DOLLS FOR TEENS

When creating doll and teddy clothes for teens, be sure to use images appropriate to the age group, such as photos of the teen's favourite band, a sport star, or their schoolfriends for the photo collage. Remove the text or replace it with something appropriate.

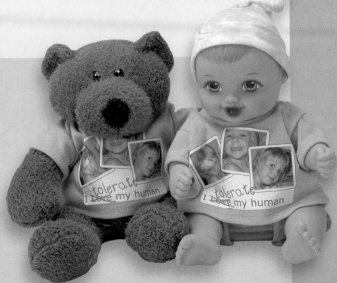

Tee time!

This technique is perfect for decorating dolls' clothes. Dolls' clothes are available from craft suppliers, but you can make your own.

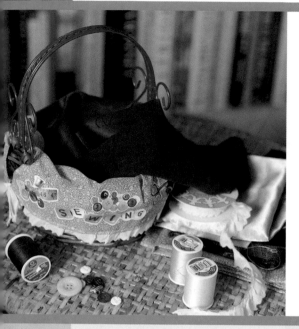

Sewing Basket

This is the perfect project for transforming a mundane object – a basket for storing sewing and knitting tools and materials – into something attractive. Here, a pretty basket liner is decorated using iron-on transfer paper, printed with letters of the alphabet. The letters can spell any word and can be adhered to fabric of any colour or pattern. The basket liner is simple to make and can be decorated to reflect different occasions simply by choosing different fabric and photographs to decorate it.

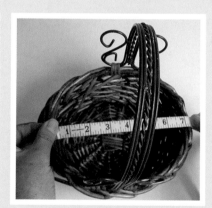

1 Measure the diameter of the top of the willow basket. This basket is approximately 17.5cm (7in) in diameter.

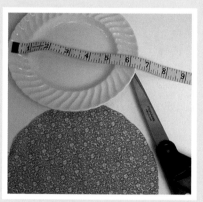

2 To make the fabric circle for the bottom section of the basket liner, invert and position a plate or bowl, approximately the same diameter as the bottom of the basket, plus 1.25cm (½in), on the fabric. Use a pencil to trace the perimeter of the plate or bowl. Use scissors to cut out the marked circle.

3 To measure the height of the basket for the skirt of the basket liner, place one end of the tape measure inside the bottom of the basket, bringing the length up and over the top and down the side for the overhang. Our height measures 17.75cm (7in).

4 Add 1.25cm (½in) to the measurement from step 3 to cut two sections of fabric equal in width to the diameter of the basket. Here, the two sections are 19 x 35.5cm (7½ x 14in).

5 Take a fabric section and turn under a 5mm (¼in) hem on one long side using straight pins. Machine stitch to secure. Sew a basting stitch along the opposite long side and use to gather the edge evenly into a soft ruffle. Repeat with the second section of fabric.

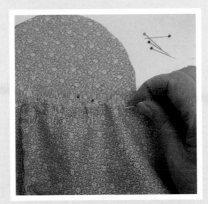

6 To join the sections of fabric, lay right sides together, short sides matching. Pin them, matching the gathered edges. Machine stitch halfway along the short sides, 1.25cm (½in) in from the edge so that hemmed edges are unattached, to make the skirt. Fold the skirt in half widthwise, matching short seams, and again to find the centrepoint of each section. Use a pin to mark on each edge.

7 With right sides together, pin the gathered side of the section of fabric to the circle. To join the gathered skirt to the fabric circle, line up the seams with the pins that mark the halfway points around the circle.

8 As you work around the circle pinning the edges, ease or tighten the gathering so that the seams continue to match up to the pinned marks. Sew the circle to the skirt, allowing for a 1.25cm (½in) seam, and removing pins as you work.

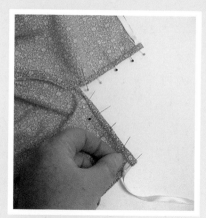

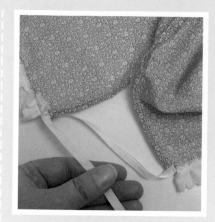

Tips

✳ EMBELLISH IN 3D

Add real buttons as a fun and dimensional finish for this project. Sew one or two small buttons over the buttons on the transfers that you've applied to the liner. This gives the project an added dimension.

9 At the open side seams, fold under a 1.25cm (½in) hem on each side and pin flat. Attach a length of ribbon to each open end under the hemmed edge. Machine stitch these edges.

10 For a decorative finish, measure and cut lace equal in length to the circumference of the skirt, plus 2.54cm (1in). Pin to the inside of each long edge and sew.

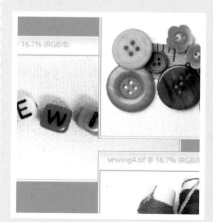

11 Photograph sewing notions and buttons or use the images sewing1.tif, sewing2.tif, sewing3.tif, sewing4.tif, and sewing5.tif from the download site (http-design. com). Open the images in Photoshop Elements.

12 Select one of the images. Choose **Enhance>Adjust Color, Adjust Hue/Saturation** and check the Colorize checkbox. Adjust the Saturation slider to the left to remove most of the colour from the image. Adjust the Hue slider until you have a colour you like. Select OK.

13 Repeat step 12 with the remaining images, making sure that each matches the colour.

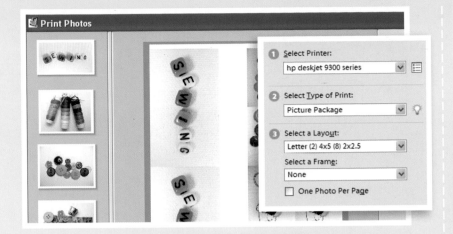

14 To print the images, choose **File>Print Multiple Photos** and, from the Select Type of Print list, choose Picture Package. From the Select a Layout list, choose Letter (2) 4 x 5 (8) 2 x 2.5 and drag and drop the images onto the sheet as shown. Print onto the ink-jet transfer fabric.

15 Use scissors to cut around each printed image on the sheet. Peel the backing paper from the image when ready to adhere to the basket liner.

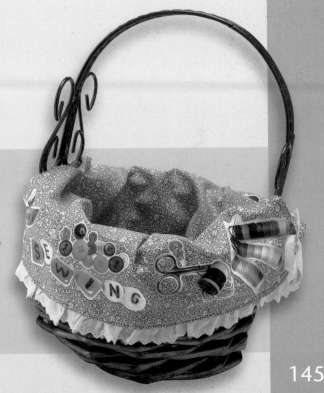

16 Arrange the elements on the edge that will overhang the basket and iron into place following the manufacturer's instructions. For this project, place a layer of tissue over each image and iron with a hot iron. Assemble the liner by placing it in the basket and tie the ribbons around the basket handles.

One basket lined up!

Of course, you can apply the idea to line baskets that display Easter eggs or hold freshly baked bread or children's toys.

Roller Blind

Papers that utilize an adhesive backing have revolutionized the way home interiors are decorated. The craft paper is heat-activated and has a backing attached that can be peeled away, revealing a sticky surface that can be easily adhered to any surface. It's handy to use when you need to affix images to anything that is not heat-resistant, such as this roller blind. Why not make a collage using the single stem of a pretty flower and a vase? It will give your window the appearance of a permanent flower arrangement.

Materials

* Vase and flower images from the download sites, or take your own photos
* Sheet of adhesive paper for ink-jet printers
* Roller blind

Tools

* Scissors
* Iron

1 Go to the download site (http-design.com) and select these images. Alternatively, photograph a slender vase or pretty bottle and a flower against a neutral background to create contrast that will make cutting out the images easier. We photographed a single flower for the vase and two lying flat. We also photographed a blue glass bottle.

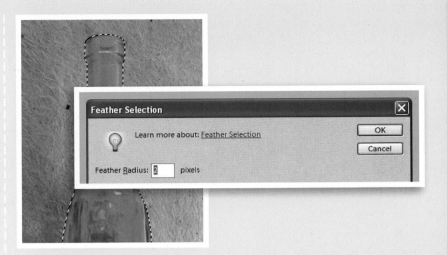

2 Open the first image. Select around the image – here, a vase – using the Magnetic Lasso tool. Tidy up the selection using the Magic Wand tool.

3 Feather the selection by choosing **Select>Feather** and set the amount to 2 pixels. This softens the edge and makes the cutout effect less obvious.

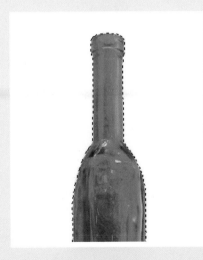

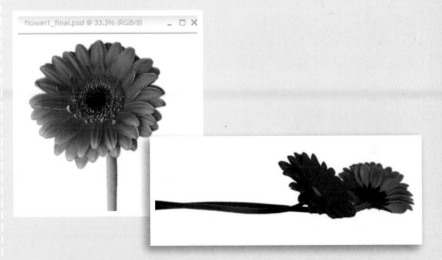

4 Invert the selection by choosing **Select>Inverse**. Set the Background colour to white and press Delete to remove the background. You should now have a blue bottle on a white background.

5 Repeat steps 2 to 4 with each flower image. When complete, you should have three images. You will need to print the flowers and the bottle or vase as separate images rather than attached to each other, so that they print large enough to look realistic.

6 Create a new image by choosing **File>New>Blank File** and set the image size to 21.59 x 27.94cm (8½ x 11in), 300ppi. Select a background colour of White.

7 Using the Magic Wand tool, click on the white background of the first flower. Choose **Select>Inverse** to select the flower. Choose **Edit>Copy** to copy it and switch to the new blank image. Choose **Edit>Paste** to paste it in.

8 Repeat steps 6 and 7 with the other two images. Size and rotate them as appropriate. Print the image at full size on a sheet of adhesive paper using the manufacturer's recommended settings for the Paper Type and Quality.

9 Empty the iron of all water, turn off the steam setting, and preheat the iron to hot. Lay the parchment paper over the image, and iron for 10–15 seconds using a sweeping motion to avoid burning the image, or as recommended by the manufacturer. This sets the ink and activates the adhesive. Allow to cool.

10 Carefully cut out each image, particularly if you are not going to adhere them to a white surface – you don't want any white margins marring the look of the project.

Tips

✳ LAYERING FOR DEPTH

When you arrange layered images such as the flower and vase in this project, take care to put the images in place in the correct order. The standing flower should be placed first so that the vase can be placed over it, giving the impression that the flower is inside the vase. Place the horizontal flowers last, ensuring that they are a little lower than the vase to give the impression that they are closer to you.

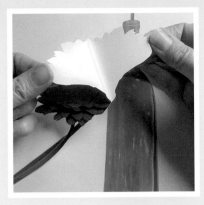

11 Peel off the paper backing from each image one at a time very carefully, taking care not to tear the more fragile print.

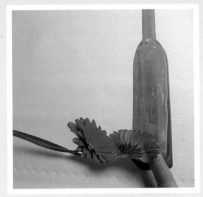

12 Unroll approximately 60cm (24in) of the roller blind and lay it on a flat surface. Position and press images to the blind. Begin with the flower that goes in the bottle and overlap the neck of bottle and the stem of the flower. Finally, adhere the flowers lying horizontally, as shown.

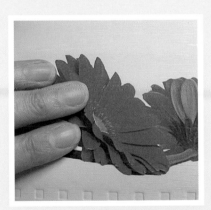

13 Smooth and press each image down carefully to make certain that all the edges adhere to the surface. Re-hang the blind when you have finished.

Roll up, roll up

This project shows just how easy it can be to refresh a tired room with something you've made yourself.

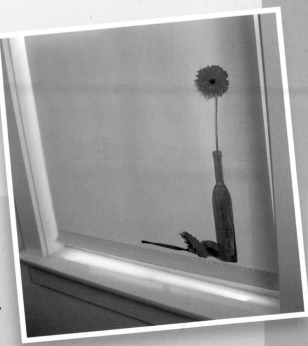

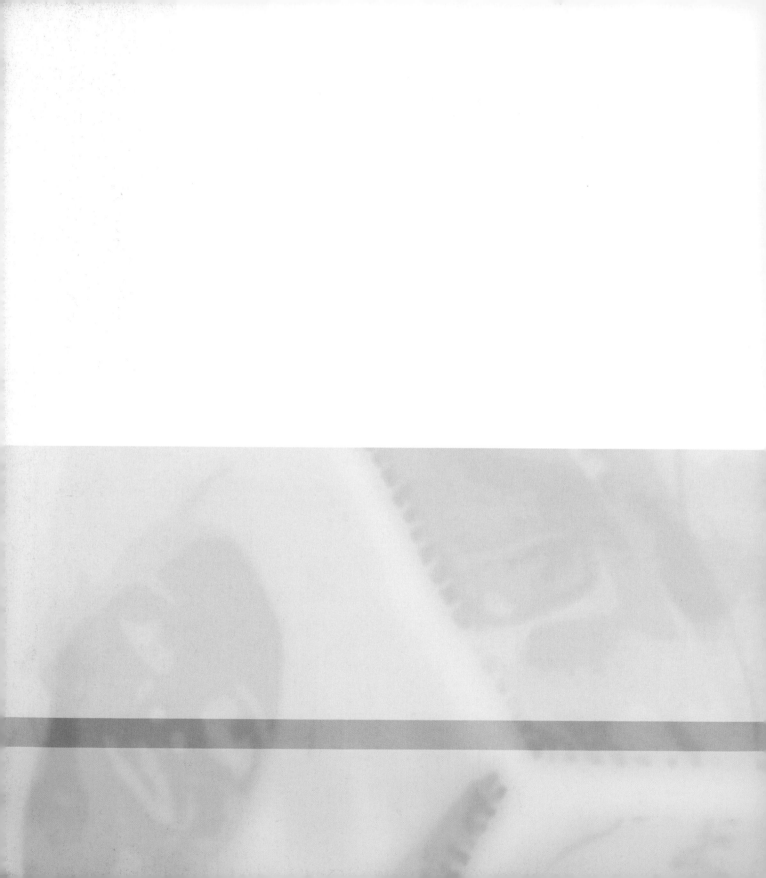

Appendix

✻ Further Resources **152**

✻ Glossary **154**

✻ Conversion Tables **156**

✻ Index **157**

✻ Acknowledgments **160**

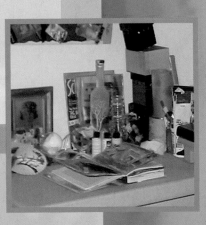

Further Resources

Papers and fabric papers

Micro Format Inc.
www.paper-paper.com
Tel: 00 1 847 520 4699
830–3 Seton Court
Wheeling, IL 60090, USA
Super Color Dark Shirt EZ transfers, Imagination Gallery fabric carrier, Imagination Gallery Super Color flip puzzle paper, SuperCal White Letter decal kit, SuperCal Waterslide Decal System (clear or white), Super Color ink-jet embossing paper, Super Color shrink art.

ScraPerfect
www.scraperfect.com
Toll-free (US): 00 1 866 644 4435
P.O. Box 42, Baldwinsville, NY 13027, USA
Perfect Printing Pouch for vellum.

McGonigal Paper and Graphics
www.mcgpaper.com
Tel/Fax: 00 1 215 679 8163
8547 School House Lane
Zionsville, PA 18092, USA
Iron-on T-shirt transfer paper (white and dark fabrics), window decals, shrink art (white and clear), flip puzzle, glow-in-the-dark transfer paper, magnetic sheets (gloss and matte), photo jigsaw puzzles, embossing paper, fabric carrier.

PrintOnIt.com
www.printonit.com
Tel: 00 1 701 667 8791
Toll-free (US): 1 800 762 4789
400 West Main Street
Mandan, ND 58554, USA
Clear static cling, Bake 'n' Shrink, Ink-jet transfer paper, opaque ink-jet transfer paper.

Lazertran Ltd (UK)
www.lazertran.com
Tel: 00 44 1545 571149
8 Alban Square, Aberaeron, Credigion, SA46 0AD, Wales
Lazertran LLC (US)
Tel: 00 1 800 245 7547
5535A N.W. 35th Avenue
Fort Lauderdale. FL 33309, USA
Waterslide decal paper for ink-jet printers.

Jacquard
www.jacquardproducts.com
Tel: 00 1 800 442 0455
Healdsburg, CA 95448, USA
Print On Silk (ink-jet printable silk fabric sheets), Print On Cotton (ink-jet printable cotton fabric sheets).

June Tailor
www.junetailor.com
Tel: 00 1 262 644 5288

Tel: 00 1 800 844 5400
P.O. Box 208
2861 Highway 175
Richfield, WI 53076, USA
Colorfast Sew-in ink-jet fabric sheets, Print 'n' Press iron-on transfer for ink-jet printers, Create 'n' Stick repositionable adhesive sheets, Art-Wear design sheets, Quick Fuse ink-jet fabric sheets.

Milliken (Printed Treasures range)
www.printedtreasures.com
Tel: 00 1 866 787 8458
Printed Treasures washable fabric sheets for ink-jet printers, ink-jet printable washable iron-on fabric, ink-jet printable peel-and-stick fabric.

Avery Dennison
www.avery.com
Tel: 00 1 800 GO AVERY
50 Pointe Drive, Brea, CA 92821, USA
Personal Creations ink-jet printable cotton fabric, Personal Creations T-shirt transfer paper for light and dark fabrics, magnet sheets.

Hewlett Packard
www.hp.com
Tel: 00 1 888 999 4747
Iron-on T-shirt transfer sheets.

Clip Art, photos, and templates

There are plenty of sites with free and for fee clip art, stock photos, and photo templates for download and purchase.

CottageArts
www.cottagearts.net
Clip art and photo templates.

Microsoft Clip Art and Media
http://office.microsoft.com/clipart/
Clip art and photos.

CreatingOnline
www.creatingonline.com/stock_photos/
Free stock photos.

FreeImages
www.freeimages.co.uk/
Free stock photos.

Stock Exchange
www.sxc.hu

Gimp-Savvy
http://gimp-savvy.com/

The Vintage Workshop
www.thevintageworkshop.com

Dover Publications
www.doverpublications.com

Averyl's Attic
www.averyl.com/attic

Background Artz
backgroundartz.com

Fonts

There are thousands of free font sites, but most are just plain awful to look at and worse to use. Here are some good font sites.

Creativespirits.net
www.creativespirits.net/typeface/

Font Garden
www.fontgarden.net/

DaFont
www.dafont.com/en/

MyFonts
www.MyFonts.com

Books

Easy Transfers for Any Surface: Crafting with Images and Photos
Livia McRee
Rockport Publishers (2002)
ISBN: 1564968510

How To Do Just About Anything With Your Digital Photos: Digital Scrapbooking, Image Enhancement, Creative Projects, Web And E-mail Sharing
Graham Davis
Reader's Digest Association (2004)
ISBN: 0762104937

Photo Art & Craft: 50 Projects Using Photographic Imagery
Carolyn Vosburg Hall
Krause Publications (2001)
ISBN: 0873419723

The New Book of Image Transfer: How to Add Any Image to Almost Anything with Fabulous Results
Debba Haupert
Lark (2004)
ISBN: 1579905293

The New Photo Crafts: Photo Transfer Techniques and Projects for Fabric, Paper, Wood, Polymer Clay, & More
Suzanne J. E. Tourtillott
Lark Books (2001)
ISBN: 1579902030

The Photoshop Elements Book for Digital Photographers
Scott Kelby
New Riders Press (2003)
ISBN: 0735713928

Glossary

Acrylic paint

Made from pigments suspended in an acrylic resin, these paints are water-soluble until dry. Once dry they form a barrier that is water-resistant. While artists' acrylics typically come in a tube in limited colours, crafters' acrylic paints are sold in 2oz jars in a large range of colours and metallic finishes and are considerably less expensive.

Aspect ratio

The ratio of the height of an image to its width. When resizing an image it is essential the aspect ratio remains unaltered so the image is not deformed or squashed. This can generally be achieved by holding down the Shift key as you drag on an image handle.

Background colour

A colour that will be used when an eraser is applied to a background layer in an image or that is used when an area is cut from a background layer. The Background colour appears with the Foreground colour in a box at the foot of the Tools palette.

Download

To move files, images, fonts, or programs from one computer or device to another. Typically, you will download from the Internet on a computer or you will download images from a camera to your computer. Unless and until they reside on your computer, you can't generally do much with them.

Embossing powder

A light powder made of tiny plastic particles that sticks to wet surfaces like wet ink. When heated with an embossing gun the powder melts to a shiny and solid surface.

Eyedropper tool

Used when selecting a colour, it allows you to sample a colour from an image. This tool is useful when matching a colour for text with colours in the image.

Feather

An area around a selection, measured in pixels. Feathering a selection makes the edges of the selection less obvious when it is copied or moved or when some effect is performed on it.

Filter

A process applied to an image that changes or distorts it. For example, a blur effect removes some of the focus from the image, and a watercolour effect makes the photo look as if it has been painted. Effects are generally customizable, so you can apply whatever amount of the effect you want to a given image.

Font

A series of characters in a similar style, typically including A-Z, a-z, 0-9, plus some punctuation symbols that are stored in a file on your computer. You can select a particular font, and, when you type, the characters appear in that style. Fonts must be installed before they can be used.

Foreground colour

A colour selected with a tool such as the Paintbrush or for text added to an image. The foreground and background colours appear in boxes at the foot of the Tools palette. See Background colour.

Gesso

A paint with glue in it used to prepare surfaces like canvas and wood for painting. If you don't use gesso first, the paint will be absorbed into the wood and you'll have to use more to achieve a quality finish.

Hue

Pure spectrum colours, such as red, orange, yellow, green, blue, and purple. In Photoshop Elements 3.0 the Hue adjuster is a horizontal slider which can be moved from Red (at 0) through Yellow to Green, Blue, and then Purple and back to Red again at value 360.

Lasso tool

A selection tool that allows you to make freeform selections around an object in an image. Typically used when the object does not have a regular shape.

Layer

A level in an image. Layers are managed in the Layers palette and each layer can contain a portion of an image. Image data on the top layers blocks out image data on layers beneath. Layers can be made partially transparent using the Layer Opacity slider.

Opacity

A measure of the image's transparency, for example: how much you can see through an image. If Opacity is 100%, the image is not transparent, if it is 0% Opacity it is fully transparent. From 0 to 100% Opacity, the image becomes increasingly less transparent and more opaque.

Paper Type

A description of the type of paper being used. Setting Paper Type correctly is important as different papers absorb different amounts of ink. Shiny paper absorbs less, so selecting this type lays down less ink than a highly absorbent paper type such as plain copy paper.

Page size

The size of the paper you are printing on. In the US, this is typically Letter size (8.5 x 11in or 21.59 x 27.94cm) and in the UK it is A4 (8.27 x 11.69in or 21.0 x 29.7cm). It is important you set this correctly as your printer might otherwise print beyond the edge of the paper.

Print Quality

This is the measure of the quality of the printout. At low quality, fewer dots per inch of ink are printed on the paper, less ink is used and the final image is not as well-defined or as saturated as it might be. At high-quality, the maximum dots per inch are printed, printing is slower, but generally the result is a more detailed, colourful result. However, when working with craft papers, often high-quality printing lays down too much ink, so choosing lower-quality printing yields a cleaner print.

Print Size

This is the size of the printed image on the page. It will be the same as or smaller than the Paper Size. Some new printers can print borderless so the Print Size is the same as the Paper Size, but older printers leave a border around the image so the Print and Paper Size don't match.

Printer Properties dialog

A dialog that displays options for configuring your printer to print a particular project. For best results, it is critical that you set up your printer so the settings match those recommended for the paper you're using.

Rotate

To turn an image around a central axis so the edges that were formerly horizontal and vertical appear at an angle.

Saturation

A measure of the intensity of a colour or colours in an image. At high saturation the colours are bright and deep and at low saturation they are muted and grey.

Selection

An area on an image surrounded by a selection marquee and which can be operated on independently of the remainder of the image.

Skew

To deform an image so that it is no longer square.

Conversion Tables

These tables will help you convert the various measurements used in the projects and the paper sizes used for printing

Paper Types/Dimensions

UK	METRIC	IMPERIAL
A4 Paper	210 x 297mm	8.27 x 11.69in
A5 Paper	148 x 210mm	5.85 x 8.27in

US	METRIC	METRIC
Letter	216 x 279mm	8.5 x 11in

Measurements

IMPERIAL		FRACTIONS OF AN INCH		METRIC	
1ft	12in	¾ in	2cm	1cm	10mm
1yd	36in	⅝ in	1.6cm	1m	100cm
1in	2.54cm	½ in	1.27cm	1cm	0.39in
1ft	30.48cm	¼ in	6mm	1m	39.37in
1yd	91.44cm	⅛ in	3mm		

Index

A

ABCKids font 140
acrylic paint 36, 44, 62, 96, 122
acrylic varnish 108
Action Is Shaded font 25
adapting designs 20, 120
adapting projects 76, 128
 baskets 145
 for boys 27
 for teens 141
 T-shirt 133
 toys 51
adding decorations 103
adding shadows 75
adding text 25, 49, 53, 76, 79, 83, 101, 114, 139
adhering adhesive image to fabric 89, 93
adhering decals 27, 30-31, 38
adhering image to fabric 65, 77
adhering window cling 35
adhesive fabric 92
adhesive fabric for ink-jet printers 74, 86, 90
adhesive jewels 104, 106
adhesive mesh 122
adhesive paper 122
Adobe Photoshop 11
Adobe Photoshop Elements 10, 11
angel pillow 66-9
antiquing medium 36
appliqué pillow project 58-61
aprons 74-5, 126-9
Arial font 139

artist's gesso 44, 96
aspect ratio 59, 112
assembling badges 115
assembling pillows 68
attaching key-ring to tag 110

B

baby bibs 118-21
babygrows 118-21
babywear 118-21
backing fabric 82
badges 112-15
bag making 80-81, 92
bags 86-9, 90-93
baking shrink plastic 110
banner making 64
basket liner 142-5
basting thread 66
bead caps or finials 62
beaded fringe 111
beads 78, 108
Bickley Script 83
black-and-white images 113
blanket stitch 89
blanket stitch appliqué 61
block of wood 40
border 64
border round images 139
bottle caps 122
box 36
brads 112
Brush tool 29, 75, 108
brushing paint on 19
business cards 100
buttons 36, 144

C

Cabbage Patch® doll 72
canvas bag project 86-9
cardboard backing 96, 99
ceramics
 decorating with decals 28-31
chair cover 134-7
changing size of pillow 68
Character Map 79
children as crafters 20
child's bedroom window decal project 32-5
child's bicycle project 24-7
Christmas banner project 62-5
Christmas ornament project 122-4
clamps 40
cleaning windows 34, 35
clip art 15, 118
clock 40-43
clock hands 40
close-ups 10
coiling wire 124
Color Mode 70
Color Picker tool 101, 131
Color Variation option 63
Colorize option 144
colour correcting 87
colouring image 131
computer 10
configuring printer settings 13
container for water 14
converting image to monochrome 54
Cookie Cutter tool 25, 29, 49, 59
copying photographs 16

copyright 15
cord 62, 78, 90
Corel's Paint Shop Pro 11
costume jewellery 96
Cottagearts.net 15, 44, 82, 100, 104, 118
cotton apron 126-9
cotton fabric for ink-jet printers 70
craft glue 36
creating borders round images 139
creating images 25-6, 70-71, 74-5, 78-9, 82-3, 101-2, 118, 144
Crop Marquee 53
Crop tool 49, 53, 63, 76, 108, 127
cropping images 59, 113, 127, 130, 138
cushion see pillow
cutout images 28-9, 63
Cutout option 131
cutting mat 14, 82, 100, 112

D

decals 16, 18
 for privacy 34
on opaque surfaces 48
decorating the clock face 43
decoupage 18
decoupage mirror project 44-7
digital camera 10-11
digital photo manipulation 11
dimensional adhesive 96, 122
dimensional effect 104
disposable foil pan 108

distressed finish 98
dog bowl project 28-31
doll clothes 70-73, 138-41
double-sided tape 44
dowel 62
download site *see Cottagearts. net; http-design.com*
downloaded image 44
downloading doll's dress pattern pieces 72
downloading photographs 16
Draft option 113
drill and drill bits 14, 40
Duplicate Layer 25
duplicating an image 25

E

E6000 glue 104
earring posts 104, 106
earrings 104-7
Edge Fidelity 131
Edge Simplicity 131
Elliptical Marquee tool 25, 49, 76, 122
embellishments 144
embossing heat gun 19, 104
embossing paper 17, 104
embossing powder 19, 104, 106
embroidery floss 66
Eraser tool 71, 75, 119
ergonomic chair 10
Eyedropper tool 71, 87, 119

F

fabric carrier paper 17
fabrics 14, 62, 142
fantasy photos 74
faux suede fabric 66
Feather option 28, 33, 63, 87, 91, 128, 136, 147
finding centre of circle 41
fitting photo in frame 99
fixing heat-set adhesive paper 125
fixing image from transfer paper 121
fixing images from heat set adhesive paper on roller shade 148-9
fixing images from T-shirt

transfer paper 129, 132, 137, 141, 145
flatbed scanner 11
Flatten Image option 119
Flip option 127
fonts 15, 31, 139-40
frame corners 96
freezer paper 82
Fuzziness slider 87

G

gathering fabric 69
glass
 decorating with decals 52-3
glass plaque 52
glow-in-the-dark transfer paper 130
Glowing Edges option 91
glue 14, 96, 104
glue dots 96
gluing 18
Good Dog Cool font 31
greyscale 54

H

hammer 14, 40, 44
handsewing 19
hanging a banner 65
hanging a mirror 47
hanging a picture frame 99
head pins 108
heart shaped earrings project 104-7
heat-activated adhesive paper 146
heat-embossing 104, 106
heat sensitive materials and printers 12
heat transfer paper 17, 19
heating 19
heatproof surface 138
hexagon, creating 59
hole punch 14, 40, 108, 112
hot-glue gun and glue sticks 14, 36, 39, 100
http-design.com 70, 79, 126, 136, 144, 146
Hue slider 91, 131
Hue/Saturation option 113, 144

I

ink-jet printable transfer paper 142
ink-jet printer 12
 and fabric 17
ink-jet transparencies 115
inserting a photo 49
inserting cord in bag 81, 93
instruction sheets 16
Internet 15
Invert option 91
iron 14
iron-on transfer paper 134
ironing board 14, 74

J

jewellery findings 14
jigsaw puzzle paper 17, 96
jigsaw puzzle picture frame 96-9
journaling 102
jump rings 108

K

key ring 108
key ring with beaded fringe 108-11
kitchen apron project 74-5
kitchen clock project 40-43
knitting needle 122

L

lace 36, 142
laser printer 12
laser printer transparencies 115
Lasso tool 75
lavender bag project 19, 78-81
Layer palette 70, 75, 101, 119
layering images 149
Lazertran decal paper 16, 31, 38
lightening photographs 47
linen fabric 90

M

Macintosh 11
macro lens 74
Magic Wand tool 33, 63, 127, 136, 147, 148
Magnetic Lasso tool 33, 62, 75
magnetic paper 17, 100
making hour markers 41-2
making up chair covers 134-7
mask and goggles 55
materials 14
matte board 96, 99, 112
memorabilia 36
memory box project 18, 36-9
Memory Page Template 82, 100
memory quilt project 19, 82-5
Microsoft Windows 10
miniature portraits 122
mirror 44-7
model train project 48-51
monochrome 54
mottled pattern 45
Move tool 71, 101
mulberrry paper 122
multiple images 132
muslin 82

N

nail file 14, 104
nails 14, 40, 44
needle-nose pliers 14, 108
needles 14
negative image 91
novelty papers 17

O

office transparencies 17, 112
oil-based vanish 31
Opacity slider 75
outline font 26
oven 19, 108
oven mitt 108

P

paint remover 50
paintbrushes 14, 18, 36, 52, 96

Paintbucket tool 24, 25, 26, 48, 71, 78
painting out background 109
paper size 13
paper trimmer 14, 36
paper type 13
pattern pieces 72
paw print 29
peel-and-stick decals 18
peel-and-stick fabric 62
pencil 82, 108, 112
pencils 14
Perfect Printing Pouch 115
photo printer 12
photographs 16
Photoshop format (PSD) file 83, 102
picture frame 96-9
picture frame alternative 55
picture hooks and wire 44, 96
pillows 58-61, 66-9
pins 14
pizza pan 40
plain paper 70, 96, 104
pliers 108
pop art T-Shirt 19, 130-33
popsicle stick 122
portrait badges 112-15
preparing wood 45, 98
print quality 13
printable fabric 17, 58
printable materials 16-17
printable vellum paper 112
printer 12
printing 26
 on adhesive paper 123
 decals 37, 41
 on embossing paper 106
 on fabric 17, 60
 with freezer paper 84
 on heat-set adhesive paper 148
 on magnet paper 102
 multiple images 30
 on puzzle paper 97
 on shrink plastic 109
 on silk fabric 67, 80
 on transfer paper 120, 132, 136, 140, 145
 transparencies 115
 on vellum 113, 115
 window cling 34
puzzle paper see jigsaw puzzle paper

Q

quartz clock movement 40
quilt batting 82
quilt making 84-5

R

realistic images 147
recolouring images 63, 91, 113, 119
recommended printer settings 16
Rectangular Marquee tool 112, 138
refrigerator magnet project 100-103
Remove Color option 113
removing decals 50
removing paint 50
Replace Color option 119, 131
resizing images 105, 123, 127
resizing magnets 103
resizing text 114
reversing images 34, 49, 127
ribbon 142
rickrack 66
roll pillow 66
roller blind project 146-9
rotary cutter and ruler 14, 82, 100
ruler 14

S

safety 7, 54
safety glasses 40, 108
safety pins 14, 78, 90
sandpaper 14, 44, 96
Santa Claus 62
satin fabric 66
satin stitch 92
Saturation slider 91
scanner 11
scanning images 112
scanning items 62
scanning memorabilia 39
scissors 14
scrapbook page 100
scrapbook template 82
Scraperfect 115
sea glass 100

seam allowance 67, 137
seashells 100
seasonal imagery 76
selecting image 40-41
selecting part of an image 28, 33, 40, 87, 90-91, 122, 136, 146
self-adhesive pins 112
Selfish font 101
sewing 19
sewing basket 142-5
sewing machine 14, 19
shadow effect on text 49
shantung fabric 66
Shape palette 29
Shefveland, Michelle 15
shoe bag project 90-93
shrink plastic 17, 19, 108, 109
signs 100
silhouetting images 33
silk fabric for ink-jet printers 66, 78
sizing images 50, 97
skill levels 20
slip covers 134
SLR camera 10
snaps 134
soft cloths 118
software 11
source material 15-16
special characters 79
sponges 14, 122
sponging paint 19, 45, 123
spray for setting ink 54
spray quilting adhesive 50, 61, 66, 68
stained glass paint 34
still life, setting up 40
Super Color embossing paper 106

T

T-shirt 130-33
T-shirt transfer paper 17, 118, 126, 130, 138
taking photographs 32, 58, 86, 90, 126
tape measure 14
tassels 65, 134
tearing paper 124
teddy clothes 138-41
test print 97

text 45
Text tool 83, 101
thread 14
toys
 decals on 51
transparency for ink-jet printers 112
Transparency option 113
trimming
 badges 114
 key tag 110
 paper 103
tweezers 14, 40, 104
Type tool 114

U

utility knife 14, 96, 118

V

varnish 36, 52, 55
Velcro 70
vellum 17, 112
Vellum option 113
Verdana font 139
vintage photos 36

W

waffle-weave cotton fabric 134
walking foot attachment 82, 85
Warp style 26
Warp Text 76
washability 84, 121
water-based varnish 27, 51
Waterslide decal paper 18, 24, 27, 28, 36, 38, 40, 43, 52
wedding plaque project 52-5
whipstitching 69
willow basket 142
window cleaner 32
window cling 32
window decorations 32-5
wire cutters 14, 108, 122
wood frame 44, 96
workspace 10
wraparound text 45
www.getfreefonts.com 25

Acknowledgments

Supplies

Sincere thanks to all these companies that generously provided supplies for the projects in this book:

Cottagearts.net
Lazertran Ltd
Micro Format Inc
Milliken (Printed Treasures)
Jacquard
June Tailor
Hewlett Packard
Avery Dennison

Designers

Michelle Shefveland
Refrigerator magnet
Memory box

Michelle Shefveland and Mary Billig
Memory quilt

Helen Bradley, Andrea Berry, and Debbi Young
Shoebag
Chair cover
Canvas bag
Angel Cushion
Doll's dress
Sewing basket
Appliqué cushion
Christmas banner
Lavender bag

Helen Bradley and Michelle Zimmerman
Christmas ornament

Helen Bradley and Debbi Young
All other projects

Photos/art credits

Helen Bradley
Michelle Shefveland
Brenda Smith
Debbi Young
Anne Collins
Michelle Zimmerman

Thanks also to Michelle Zimmerman for the use of her Santa statue made from an original design by Maureen Carlson; Michelle Shefveland, David Hole, Diana Brélaz, Michelle Zimmerman, Debbi Young, Jenny, Shaun, Casey, Allison, Brandi, Stephanie, and Ginger for the use of personal photos.

Writing a book like this is a team effort and I've been blessed with working with a wonderful group of people. Special thanks to Michelle Shefveland from CottageArts.net for her encouragement and support, to Tom Mugridge, Tony Seddon, and Kylie Johnston at Ilex Press for all their hard work in getting the book to press. Closer to home, a heartfelt thanks to Michelle Zimmerman, Debbi Young, Andrea Berry, and Maryann Smith, whose dedication and hard work is so very appreciated.

The Publisher would also like to extend grateful thanks to the following for their generous help:

Rebecca Saraceno and baby Aidan
Sophie Collins
Emma Frith
Tim Pilcher